LOST
CHARLESTON

LOST
CHARLESTON

J. GRAHAME LONG

FOREWORD BY
KATHERINE SAUNDERS PEMBERTON

THE
History
PRESS

Published by The History Press
Charleston, SC
www.historypress.com

First published 2019

Manufactured in the United States

ISBN 9781467139045

Library of Congress Control Number: 2018966272

For Lissa, Macie and Sumner…

CONTENTS

FOREWORD

Charleston has been called "America's Most Historic City," and its reputation as the birthplace of historic preservation means that visitors can come and admire the tangible remains of its storied past. Our city is famous for its old residences and civic buildings, narrow streets and charming alleys, a harbor packed with historic forts, moss-draped live oaks and church steeples puncturing the skyline. Much in Charleston has remained the same year after year, but our city has also witnessed great change and, far too frequently, loss.

Charleston was founded in 1670 and, over the centuries, has weathered countless hurricanes and tornadoes, five major fires, two wars and one giant earthquake. These natural and man-made disasters and the ebb and flow of development mean that Charleston, like any dynamic city, is constantly changing and evolving. Ironically, it was the loss of beloved residential, commercial and civic buildings over the years that instilled in Charlestonians a desire to preserve for future generations whatever remained.

But, it wasn't just buildings that were "lost." As the city changed and expanded, whole landscapes and streetscapes were transformed as well. The colonial waterfront, with its bustling wharves along the Cooper River, was landfilled and soon gave way to newer structures. The southern tip of the peninsula, which featured earthworks during the Civil War, became a tree-filled park with statues, cannons and a bandstand. Tidal creeks were filled in, with streets built atop them, and once crooked streets were straightened out. The hundreds of tall ships docked in the harbor, the old vegetable

and fruit stalls within the city market and the trolleys that once traveled down King Street are now just memories. On a smaller scale, countless personal possessions have also been "lost" to fire, wars, other disasters or simply the hustle and bustle of daily life. Thankfully, museum collections, old photographs and archaeology can provide us, in bits and pieces, with some glimpses into these bygone eras.

There is no way to record everything that has come and gone in Charleston during the last three and a half centuries. But, as we look at Charleston's lost places and "stuff," we can learn more about this amazing place and the equally amazing people who have called it home.

—Katherine Saunders Pemberton,
Associate Director of Preservation
Historic Charleston Foundation

ACKNOWLEDGEMENTS

Without help, books like this don't get started—and they most certainly don't get finished. There are many people who deserve far more recognition than I for their hard work and dedication to the preservation and study of the wonderful city we call Charleston. Some are listed below. For their help and support—and for making my life much easier throughout the process of this work—my simple thanks are nowhere near enough. They are, to be sure, scholars, unique talents and consummate professionals. They also are my friends, and for that, I am especially grateful.

Special thanks to John Young, Assistant Director, the Powder Magazine, for his masterful editing, expert fact-checking and, of course, extreme patience.

Special thanks as well to Katherine Saunders Pemberton, Associate Director of Preservation, Historic Charleston Foundation, for her valuable advice and input.

Dr. Nicholas M. Butler, Archivist and Historian, Charleston County Library; Douglas W. Bostick, Executive Director, South Carolina Battleground Preservation Trust; Dr. Eric Poplin, Senior Archaeologist, Brockington & Associates; Juliana Falk; Jennifer McCormick, Archivist, The Charleston Museum; Martha A. Zierden, Curator of Historical Archaeology, The Charleston Museum; Sarah Platt, PhD candidate, Syracuse University; Sarah Stroud Clarke, Archaeologist and Curator of Collections, Drayton Hall; Kim Graham, photographer; Chad Rhoad, Senior Commissioning

Editor, The History Press; Lauren Northup, Director of Museums, Historic Charleston Foundation; English Purcell, photographer; Dale Thieling, Executive Officer, and the gentlemen of the Washington Light Infantry; Tony Youmans, Executive Director, The Old Exchange and Provost Dungeon; Nancy Kruger and Joan Holling, St. Matthews Lutheran Church.

1

THE LAY OF THE LAND

I n the summer of 1766, a loose contingent of just over two dozen merchants, tradesmen and others gathered under what they were by this time defiantly calling the "Liberty Tree," located somewhere near the present-day corner of Alexander and Calhoun Streets. This group, under what some termed as the aggressive—or perhaps even traitorous—leadership of Charleston's own Christopher Gadsden, railed against all British taxes past and present, further imparting "warnings of future tax-related attacks on colonists by Parliament."[1]

Most Charlestonians nowadays are familiar with this story as one among many others within the catalogue of American opposition to British rule. Yet, at some point, one must ask: What became of this revered icon that, as some argue, birthed South Carolina's first real organized venture into what the British, no doubt, considered high treason? The answer is a simple, albeit a far too common one, when considering the many colonial-period landmarks that once peppered the vast Carolina Lowcountry: it is forever lost.

Now, it should not be at all surprising that a tree, of all things, is no longer standing in an ever-growing city like Charleston. Cities expand unavoidably, naturally even, and, therefore, speedily and permanently alter their surroundings. Charleston is, after all, as former mayor Joseph P. Riley Jr. stated, "an incomparably beautiful, yet somewhat fragile city."[2]

Still, there seems a terrible undertone to the word *lost*, especially in a city like Charleston, a place that is internationally renowned for its preservation efforts. *Lost* carries with it strong emotion, more severe certainly than *renovated*, *removed* or *repurposed*. With *lost*, there is no going back.

Fortunately, Charlestonians learned this valuable lesson nearly a full century ago, and some would contend even further back than that. Noted eighteenth-century physician and historian Dr. David Ramsay seems to have been just as like-minded, writing, "Much useful knowledge…is already lost, and more is fast hastening to oblivion. A considerable portion of it can now only be recovered by a recurrence to tradition—for records of many events worthy of being transmitted to posterity have either never been made, or if made have been destroyed."[3]

Historical preservation must battle almost daily with modern development. Whether to "progress or protect" seems an all-too-familiar and, worse, consequence-laden choice. Charleston is at a critical stage, and preservation must continue to be advocated and supported. An 1885 newspaper article obliquely touched on this subject, with an odd combination of ebullient boosterism and breathtaking naiveté, proudly proclaiming:

> *New residences are being erected and old ones remodeled and improved. Real estate is advancing in value. But with all the modern innovations, Charleston still retains its old-time characteristics and grows more interesting as the years go by. The substantial old architecture of half a century ago seems not to heed the passing years and the quaint old houses, with roofs and broad verandas, surrounded by the walled flower gardens will recall the days of "auld lang syne" for many a generation to come.*

The writer got it wildly wrong; modernity is the natural enemy of preservation.[4]

It is also important to keep in mind (although risky to state aloud among certain circles) that not all which was lost is universally missed. For example, before its merciful demolition, 529 King Street (constructed in the early 1950s and once home to the storied Dixie Furniture Company) had, according to a respected local architect, "no architectural value….We take architecture very seriously in Charleston, and by every measure this building falls short." He was right, of course. Only adding to its aesthetic woes were its upper-level exterior "windows," which when observed a bit more closely, were just sheets of crudely painted and plastic-covered plywood, probably installed there sometime in the 1970s. A new hotel is currently in the works to take the old building's place.[5]

Another challenge for Charleston is regional, national and international tourism. The city has received repeated accolades from myriad publications as "the best," "most livable" or "friendliest" city in the nation or, better still,

the world. Indeed, today's Charleston welcomes more visitors per capita than Amsterdam or even Barcelona. And of course, all these travelers need food, housing and entertainment. These pressures lead to additional demands for land, leaving the city and its surroundings hovering at a crucial point. This unprecedented growth continues to swallow up neighborhoods, nay entire historic communities.[6]

Naturally, and alas, unsurprisingly, as many consultants are quick to point out, "The problems are similar in Charleston and pretty much any place [else]…but solutions are hard to come by." Simply put, Charleston has lost quite a few of its landmarks, its buildings and its very landscape, for any number of reasons. Therefore, if one were to examine "The Holy City" (a common Charleston sobriquet) in terms of what has been lost, one would first have to know what had *been*, and it would be essential to begin with the very *foundations* of English settlement.[7]

THE WALL

When British cartographer Edward Crisp drew one of his more famous maps in 1711, he noted, "This flourishing province produces Wine, Silk, Cotton, Indico [*sic*], Rice, Pitch, Tar, Drugs, & other Valuable Commodityes [*sic*]." Indeed, the seemingly endless supply of crops and natural resources that the early colonists harvested and exploited soon gave rise to wealth-creating enterprises, the likes of which none of the original eight English Lords Proprietors could have ever imagined. Yet with this good fortune came countless trials.[8]

Although there are several remnants of the old city wall, the most accessible is a small curved section below the Old Exchange and Provost Dungeon, a magnificent building constructed between 1768 and 1771 at the corner of East Bay and Broad Streets, nowadays open as a historic-site museum. Exposed in 1965, this brick section is all that remains of the Half-Moon Battery—a small midpoint bastion named for its semicircular shape—which originally protruded from the city's east-side enclosure. This sturdy brick seawall constructed in the 1690s protected only the waterfront. The rest of the city was wide open, and with both French and Spanish enemies already eyeing English Charles Towne, by 1700, it was ripe for attack. In fact, the Spanish had previously mounted an invasion, making it as far as Edisto Island before a hurricane forced their retreat.[9]

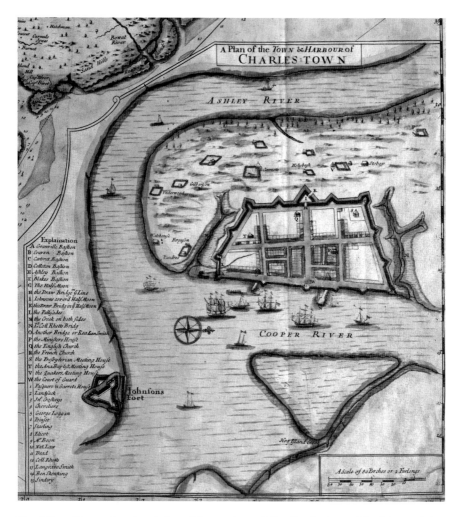

Detail from "A compleat description of the province of Carolina in 3 parts," by Edward Crisp, circa 1711, showing Charleston as a walled city. *Library of Congress, Geography and Map Division.*

In December 1703, upon the outbreak of Queen Anne's War with Spain, the Commons House of Assembly (colonial House of Representatives) wasted little time enclosing the rest of Charleston's high ground, about sixty-two acres, within a continuous wood-and-earthen fortification, placing higher, protruding and, more importantly, armed bastions at each corner and further incorporating "entrenchments, flankers, parapets, sally ports, a gate, drawbridges, and blinds." At the present intersection of Meeting and

Broad Streets stood "Johnson's Ravelin," which held at least one drawbridge and served as the land entrance into the fortified city.[10]

The wall, once complete, made Charleston the only English walled city in North America. Add to that several bastions, batteries and other defenses constructed over the next eighty years, and Charleston was "the most heavily fortified British city on the continent." These works, for the most part, did their job admirably. When Florida-based Spanish invaders returned in 1706, this time accompanied by French and Native American combatants, the surrounding walls provided welcome peace of mind to the South Carolina militiamen, who needed only four days to capture upward of 320 enemy invaders and kill another 30.[11]

In time, as economic prosperity spread within the colony, further expansion and development were required in South Carolina's capital and major port. Moreover, by 1720, the wall itself had fallen into serious disrepair, its corner bastions no longer in what the Commons House considered "a posture of defence [sic]." Unsurprisingly, as the years passed, the once impressive system of fortifications became more of a hindrance to Charlestonians, merchants especially, most of whom demanded ready access to wharves for the loading and offloading of cargo vessels.[12]

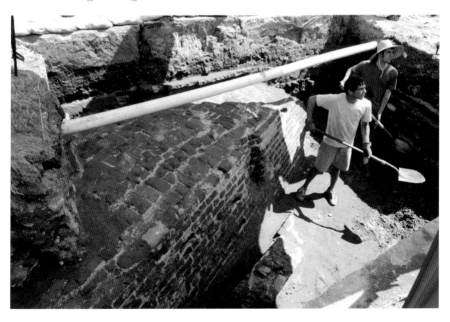

Archaeology field school students, in conjunction with The Charleston Museum and the Walled City Task Force, excavate a large portion of the wall beneath South Adgers Wharf, near East Bay Street, 2008–9. *Author's photo.*

The weather was absolutely no help. Hurricanes in 1713 and again in 1714 caused extensive damage to the walls, while even more storms during the 1720s created strong tidal surges, which undermined many of its southern sections. Making matters even worse were the residents, plenty of whom helped themselves to "earth and building materials" for their own use, their quiet looting eventually erasing the walls' 1703 rear-facing components.[13]

Today, even though the Half-Moon Battery may be the section that most people get to see, the Mayor's Walled City Task Force, a fifteen-member group of preservationists, appointed in 2005, carries out ongoing archaeological investigations and, when practicable, excavations to better research and interpret the construction and use of Charleston's former fortifications. In 2008, the task force undertook an impressive endeavor, exposing, albeit temporarily, one of the old wall's redans (a "salient angle" or a triangular projection that allows advantageous weapon fire against invading enemies), which for centuries remained buried beneath South Adgers Wharf. Although the redan site had to be backfilled, city officials in 2009 elegantly outlined its position by laying two rows of brickwork amid the cobblestone pavers of South Adgers Wharf. The Charleston Museum retained a small portion of the redan wall, which it exhibits within its permanent galleries.[14]

ASHLEY FERRY TOWN AND WILLTOWN

Naturally, the disappearance or loss of Charleston's early structures such as its walls could be easily anticipated and universally understood, especially when put in the context of the city's immensely historic landscape. What may be a bit more unexpected is how entire towns, once busy and productive places, are now lost—in effect, buried—beneath Charleston's modern suburbs.

A leisurely drive north on today's scenic South Carolina Highway 61 reveals much of the area's past, including entryways into lovely historic plantations such as Drayton Hall and Middleton Place. However, there are few hints (other than a road sign and a railroad bridge) of the major transportation hub that once anchored the west end of the Ashley River's only eighteenth-century ferry crossing. Moreover, there remains nary a clue of Shem Butler's Ashley Ferry Town, which once occupied the lands around it.

All the while Charlestonians were hard at work maintaining their walls to protect the city's urban, peninsular center, Butler was mapping out his own

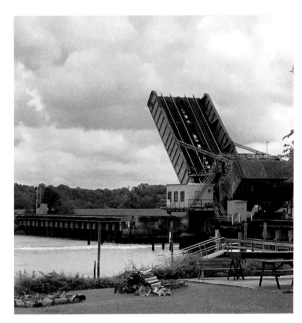

The current railroad crossing and drawbridge over the Ashley River, near Brevard Road, marks the site of the eighteenth-century ferry crossing from Ashley Ferry Town. *Author's photo.*

property on the other side of the Ashley River, diligently planning his version of what he hoped would soon become a bustling community. It was to be, he hoped, a welcome way station for travelers en route between Charleston and South Carolina's only other early municipality, Willtown, located twenty-four miles south on the South Edisto River.

For Butler, the new Ashley Ferry Town (appearing on older documents sometimes as "Shem Town" or "Butlerstown") was the product of good luck, thanks mostly to a legislative act at the tail end of 1703. A rather bold one, it ordered the connection of Willtown to Charleston by means of the construction and continued maintenance of a "Broad Path," some sixteen feet wide—or at least big enough for two carriages to pass "without hindrance." Even better, the legislation mandated a ferry crossing on the Ashley River, situated completely within Butler's landholdings.[15]

Having received 1,750 acres in land grants in July of that same year and an additional 700 the following May, Butler was primed to cash in on this new government decree. The ferry alone promised to be as busy as it would be profitable, providing "for the transporting of or carrying any passengers or travelers whatsoever, over the said Ashley River, whether on foot or horseback, or with cattle hogs, sheep, or other things." Also, as the Commons House stipulated, "[T]he landing place for the ferry at that point on the south side of the river, and the road through

the lands of Mr. Shem Butler were declared to be the road and landing place forever."[16]

To accommodate the expected traffic, Butler began developing his property. On paper, his design for Ashley Ferry Town was no small enterprise. A "grid of ten streets and 102 building lots" was laid out for the various trade shops needed by travelers, such as a blacksmith, a saddler and a wheelwright. At least one cabinetmaker operated there in 1739. Finally, an all-important brick tavern was to be built adjacent to the ferry landing.[17]

Unfortunately, neither the Commons House's nor Butler's plan materialized without a fair share of problems. Labor shortages and property disputes caused long delays that dragged out the project for almost a full decade. As for Butler, he appears to have died around 1718, well before fully realizing his master plan, which is not to say that it was an unsuccessful one.

By the 1720s, Ashley Ferry Town and its population had grown, although records are unclear as to the exact size of either. The absence of specific numbers notwithstanding, notable events there provide good evidence of an emergent community. A declaration dated September 22, 1723, for example, stated that open markets were to be held every Wednesday and Saturday, with the ferry's toll to be waived on those days. In 1738, Ashley Ferry Town served as temporary home to the Commons House of Assembly after its members had fled Charleston due to a smallpox outbreak (a repeat of which would occur in 1760, for the same reason). In 1751, William Cattell had what appears to be a permanent home in the town and later attempted, albeit unsuccessfully, to found a smaller "St. Andrew's Town" (named after the parish territory that surrounded it) to the south and east of the ferry dock. Also worth noting is an August 1760 newspaper report, announcing that "from Shem-Town, Ashley-Ferry…a bill has been brought into the Commons House of Assembly there, and had two readings, for forthwith raising a regiment of 1000 men to act against the Cherokees."[18]

Meanwhile, at the other end of the long road, which left Ashley Ferry Town and headed south toward Edisto, was Willtown. Named for England's reigning monarch William III, it was a well-established municipality, larger and certainly more populated than Ashley Ferry Town. Appearing as "New London" on early maps and documents and first conceived in the 1690s, this remarkable, yet now mostly forgotten, burg was developed to further expand the Lowcountry's lucrative rice-growing capabilities and better capitalize on the Native American deerskin trade. Willtown routinely appeared on most period maps of the region—Edward Crisp's included—and, as early as 1708,

was described as "a towne consisting of about 80 houses." Even though archaeological evidence does not support a community quite that large, it was still significant as the first colonial town established after Charleston.[19]

By the 1720s, Willtown had various residences, other buildings, a courthouse, a school and a church. Subsequent land grants expanded the town borders and brought in more permanent residents. Many of them, by most accounts, were doing quite well for themselves, building homes and planting gardens, "which lying along the River and adjoining the Town Line makes such a commodious and pleasant, as well as profitable Settlement that nothing but a very great Want of Money could make the owner part with it." Another boost to the Lowcountry economy came in 1729, when the Lords Proprietors of the Carolinas, after years of bickering, sold off their holdings to King George II, making South Carolina a royal colony. For Charleston and Willtown, the doors were now wide open for development.[20]

The remainder of the eighteenth century brought significant change to Charleston and the surrounding Lowcountry. The city expanded socially, politically and, to be sure, commercially. Rice was no longer a mere experimental crop but a serious moneymaking export—so much so that most any real estate outside of Charleston's urban center was soon viewed as far more valuable for its cultivation potential than any possible civic use.

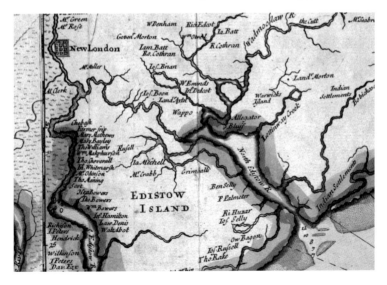

Detail from "A compleat description of the province of Carolina in 3 parts," by Edward Crisp, circa 1711, showing "New London" (a.k.a. Willtown) as a large and well-designed township (top left). *Library of Congress, Geography and Map Division.*

There were fortunes to be made, and Willtown—surrounded on all sides by rich salt marshes and fertile tidal flats, making it perfectly suited for rice cultivation—was in the way.

But this was not its sole problem. "It had a site fine in appearance being on a high bluff on a navigable stream," one historian reflected, "but its position was a bad one for any purpose of defence [*sic*]….It was not suited to trade as the easy water communication with Charleston allowed the latter to supply all the territory around it." Eventually, property owners began consolidating much of Willtown's land. They imported hundreds of slaves, quickly putting them to work digging and tilling the earth, creating ditches, dikes and fields all to facilitate rice production. By 1767, the community church sat abandoned (though a new one was planned some three miles away).[21]

Today, the Willtown settlement may be physically lost, but its importance is most assuredly not. In 1974, it was placed in the National Register of Historic Places, and the South Carolina Department of Natural Resources' Heritage Trust Program lists it as "one of the 100 most significant sites in South Carolina." Perhaps even more importantly, the current property owner has taken great strides in protecting the Willtown site, placing much of it under an easement with the Nature Conservancy, as part of the ACE Basin National Wildlife Refuge. In addition, archaeological studies of the area have proven quite beneficial, one 1996 excavation resulting in a 370-page report that helped complete Willtown's history. If only Ashley Ferry Town had been so lucky.[22]

Back on the Ashley River, control of the ferry's operation passed through the hands of numerous owners and managers, both male and female, until 1821, when it became the property of Joseph F. Bee. By then, what had become known as Bee's Ferry was a wholly unprofitable business venture, thanks to a new ferry operation located downstream, much closer to the Charleston city limits. In 1856, a new bridge ultimately doomed both Bee's Ferry and neighboring Ashley Ferry Town, and by the late nineteenth century, barely a trace remained of either.

It would take until the 1970s before Charlestonians breathed new life into the long-abandoned and overgrown site of Ashley Ferry Town, this time in the form of two subdivisions each at the eastern terminus of the constantly traffic-laden Bee's Ferry Road and S.C. Highway 61. However, only close attention will reveal the neighborhood signs for Ashleytowne Landing, which sits atop the former—and still lesser-known—St. Andrew's Town, and Drayton on the Ashley, which completely covers the former site of Ashley

Ferry Town. Regrettably, and unlike Willtown, hardly any archaeology was allowed on either location before construction began, allowing these two once ambitious colonial townships to become truly lost to history.

MARYVILLE

"But for how long?" asked one local newspaper, rhetorically, when assessing the future viability of dozens of Reconstruction-era municipalities around South Carolina's Lowcountry, most founded by emancipated African Americans. By the turn of the twenty-first century, dramatic increases in population, land prices and commercial encroachment had begun overtaking many of these locales. The Phillips Community, for instance, a once isolated region east of the Cooper River on Horlbeck Creek, held houses and buildings "in almost an Amish fashion with community members pitching in…[and] without a single bank loan." Today, Phillips is within the town of Mount Pleasant, Charleston's fastest-growing suburb. Despite concerted efforts by advocacy groups, such as the African American Settlement Community Historic Commission (established in 2017 to protect and preserve such areas), its lifelong residents still worry about the survival of not only their historic settlement but also their "culture, language, food, [and] artistic ways."[23]

When chartered in late 1886, the town of Maryville was not merely a minor burg planted on some nameless stretch of land along the western side of the Ashley River. Its very soil was, arguably, some of the most historic in the American South. Adjacent to Albemarle Point, where English settlers landed in 1670 and established the colony of South Carolina, Maryville's land once held what early records refer to as the "Proprietors' Plantation," a property originally owned by three of Carolina's Lords Proprietors. Its seventeenth-century history aside, however, most locals familiar with Maryville, especially those who grew up there, understand the uniqueness of the former town, especially in the tumultuous decades after the end of slavery.[24]

Part of Hillsborough Plantation in the eighteenth century, the roughly 550-acre tract had numerous owners throughout the nineteenth. In 1879, it was acquired by Christopher Columbus Bowen, sheriff of Charleston County. Unfortunately, Bowen died barely a year later, having never benefitted from his purchase. His widow, Mary, wedded former Union general William N.

Taft. By the late 1860s, Taft had become a successful Charleston merchant, politician and considerable Lowcountry landowner. By 1881, the couple was dividing their portion of the Hillsborough Plantation into building lots.

By the spring of 1886, Taft was frequently advertising in the newspaper that their land, "laid out immediately opposite the city on the south bank of the Ashley," was readily available. By this time, it also appears that he had abandoned the age-old Hillsborough identification in favor of "Maryville," no doubt after his wife, touting, "Some of the choicest lots at Maryville…100 by 50 feet, high, dry, and beautifully located near the city." In a year's time, "ten or twelve houses" were built, "occupied mostly by colored people, who also rent small farms, on which they raise corn, cotton, peas &c."[25]

Now, although Mary Taft co-owned the property at the time her husband named the development Maryville, it was still little more than unimproved riverside property. The boom times had not yet come; the few people living there were only starting to form a community. It is intriguing to point out that, at this exact same time, there was another woman, with the same first name as Mrs. Taft, living within this fledgling development. This other Mary—Mary Matthews Just—would become the catalyst for change, the role model for others. She would work tirelessly to make this tiny cluster of buildings into something more, and in the minds of her neighbors, *she* was the namesake for their municipality.[26]

Described by many African American residents of Maryville in the late nineteenth and early twentieth century as "the more immediate leader and founder of the Maryville community," Mary Just earned a living in the area's post–Civil War phosphate industry. She may have been among the first to purchase property within the new settlement. Almost immediately, she took charge, persuading other African Americans to purchase neighboring lots and to "transform the settlement into a town," to be managed by one of the very first "purely black governments in the state."[27]

Over the following decade, Mary Just held Sunday school classes in her home, but the extremely high illiteracy rate among the Maryville populace nagged at her relentlessly. Deciding then to spend her "life and means…to the cause of Negro education," she began teaching all manner of lessons, once again using her house as a classroom to teach "children, teenagers, and adults together in one room." On weekends, she trained others in various technical skills, such as hat-making and basic sewing. Remarkably, up until her death in 1902, Mary Just taught not only in Maryville but also in Charleston and on James Island, where she founded the Frederick Deming

Jr. Industrial School, the first learning institution of its kind for African Americans anywhere in South Carolina.[28]

Eventually, as with many small towns on the outskirts of larger ones, Maryville's independence began slipping away. By the late 1920s, Charleston's ever-increasing population had moved in earnest to areas west of the Ashley River, and by 1933, the community was struggling to maintain its sovereignty. Tensions peaked later that year when Maryville's town council, attempting to secure funds amid an already depressed economy, implemented increased fees on business licenses for all town merchants. White business owners launched an immediate protest and quickly petitioned the state to revoke the town charter as well as have the entire community annexed into St. Andrew's Parish (now part of Charleston County). For three years, the battle for control of Maryville raged. Mayor Thomas Carr held regular "dances and parties to raise money to pay the lawyers," but in the end, he simply could not compete with the General Assembly. Citing a need "to improve the policing, health, and road conditions in the township area," state legislators on June 1, 1936, voided Maryville's town charter and quite unceremoniously "legislated out of office" Mayor Carr and the town council. The "magistrate and rural policemen" of St. Andrew's Parish took control of the community. "I'm not even sure if they had the authority to do it," recalled Mayor Carr's son years later. "The only reason I can think of is because it was a colored town."[29]

Maryville lost more and more of its identity and culture over the generations that followed its forced dissolution. Its town hall was demolished in 1940. By 1989, the community had, as one journalist put it, "changed to the point of disappearing....Maryville has not been developed in the fashion of the tonier neighborhoods nearby" and "flirts with oblivion." Still, though the township had long since disappeared, its proud legacy as an example of an African American municipality founded in the post-emancipation era remained. Ultimately, refusing to allow yet another Lowcountry community to be completely lost to time and memory and referring to Maryville's disestablishment as "obviously a sad moment in our state's history," Charleston mayor Joseph P. Riley, with city council concurrence, on June 2, 1999, formally recognized the Maryville neighborhood and its former township by placing a historical marker on St. Andrew's Boulevard at the entrance to the community. Further acknowledgement of the town's place in history came by way of a legislative resolution:

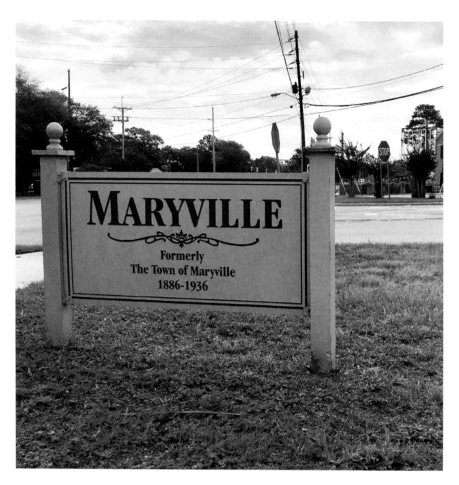

One of two markers near the corner of Magnolia and Ashley River Roads denoting Maryville's former location. *Author's photo.*

Now, therefore, be it resolved by the House of Representatives, the Senate concurring, that the General Assembly of the State of South Carolina Salutes the Maryville community in Charleston County for maintaining an identity as an African-American community for many decades, and recognizes the former town of Maryville as an African-American municipality important to the history of South Carolina.[30]

2

"SPLENDOUR OF BUILDINGS"

I n 1944, when the Carolina Art Association published its architectural survey *This Is Charleston*, the book expertly listed a large number of elegant properties around town that, in one way or another, contributed to Charleston's reputation as "a unique American city." Even then, the primary author, local architect and historian Samuel Gaillard Stoney, could not hide the obvious. Of the hundreds of houses, public buildings and churches, the word *gone* appears almost eighty times beneath those entries.[31]

A more modern sentiment might be "So what?" It is a legitimate question, albeit one that most preservation-minded folks about town might not appreciate. Indeed, people become attached to material things, whether they have a personal link to them or not. As one local psychiatrist delicately remarked, "It is an emotional belonging. To wipe out an old place, to not preserve it, is to lose a memory....We become alarmed to protect the attachment of our identity to that property." Commenting on the destruction of personal possessions, a modern journalist bluntly observed, "[W]e are throwing out the record of a life....Is it necessary? Yes. But it's an erasure that's irrevocable. Like the ash that surrounds bodies at Pompeii, these objects preserve the shape of a life." For nearly a century, insights like these have persuaded the Charleston community to protect as much as it possibly could.[32]

As for the city's pioneering preservation and protection movements, undertakings that today serve as models throughout the country, when did they begin? Most would point to 1920, when Susan Pringle Frost, a onetime

stenographer, first learned that the Joseph Manigault House, built in 1803 and the city's finest example of Adam-style architecture, was threatened with demolition to make way for an Esso gas station. This, in Frost's mind, was a disaster in the making. Having grown up in the Miles Brewton House, a grand Colonial mansion on King Street, she was acutely aware of the importance of conserving such treasured "dwellings." Moreover, she had already witnessed at least one other oil company infringement upon historic neighborhood properties and was determined never to let it happen again.

Frost spearheaded the founding of the Society for the Preservation of Old Dwellings, a remarkable organization that still operates today as the Preservation Society of Charleston, headquartered on King Street. Working together with a membership of concerned preservationists and financial supporters, Frost and the society not only saved the Manigault House (today owned by The Charleston Museum and open for visitation), but, in little more than a decade, also convinced Charleston City Council to ratify the nation's first preservation zoning ordinance. For starters, this new regulation included "a significant section on historic preservation" and "provisions that sought to protect historic architecture." Secondly, and unique for its time, Article X established an "Old and Historic Charleston District," at the southern end of the peninsula, mostly below Broad Street, along with a new Board of Architectural Review, which retained "authority over certain types of architectural changes to all buildings in this district."[33]

Naturally, even the best, most unwavering endeavors to preserve old Charleston places can fail from time to time. Unlike the Joseph Manigault House, which Frost and the society had worked tirelessly to save, the nearby home of Manigault's brother Gabriel "became the victim of lack of planned zoning," another serious casualty of the modern age. Simply put, if Standard Oil Company could not have Joseph Manigault's house, then brother Gabriel's would have to do.[34]

Gabriel Manigault was (and, most argue, still is) among Charleston's most celebrated, albeit nonprofessional, architects. While studying law in London, he became inspired by the work of Robert Adam, Britain's premier eighteenth-century architect. Returning home to Charleston after the American Revolution, he began to put his nascent architectural talents into practice, designing his own house in the late eighteenth century and his brother's soon after the turn of the nineteenth. Other structures attributed to him include the South Carolina Society Hall and the Bank of the United States building (city hall), within a block of each other on Meeting Street.

The Joseph Manigault House as seen from John Street, circa 1950. Though the house itself was saved from demolition, other modern businesses encroached on its surrounding grounds. A gas station occupied the southwestern corner, while a drycleaner occupied the northern side. *Library of Congress.*

Sadly, none of this history seemed to matter to Standard Oil, which on February 25, 1930, procured the proper zoning permits: one to build the service station and the other to demolish Gabriel's house. For Frost and the society, their streak of preservation victories through the previous decade

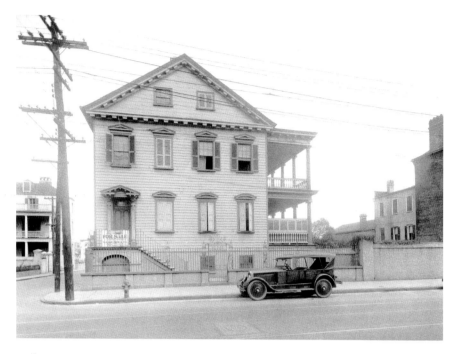

The Gabriel Manigault House, as seen from Meeting Street, circa 1930. *Courtesy of The Charleston Museum, Charleston, South Carolina.*

came to an abrupt halt. By this time, not even they could compete with the incredibly deep pockets of Standard Oil. Frost lamented, "To filling stations, as such, we have no objection, but when the large oil distributing companies single out such handsome homes as that...designed by Gabriel Manigault, the Huguenot...we feel the warfare is greater than we can wage."[35]

Down but not out, Captain Alston Deas, president of the Society for the Preservation of Old Dwellings, met with Standard Oil executive John C. King mere days before the scheduled demolition. As a result, the pair agreed that, to soften the blow of yet another important structure loss, "much of the old building, particularly those parts of any architectural value" would be preserved. Citing "harmony in architecture," King pledged the following uses for recovered features from the Gabriel Manigault House:

> *The seven Corinthian columns on the upper porch of the residence and seven Ionian on the lower...would be used in the filling station to be erected at Meeting and George and at the one to be erected at Chalmers and Meeting....Mantels from the old house will be used in the restrooms. The*

present doorway…will be used in the entrance to the ladies' rest room at Chalmers Street and some of the 12-inch planking of the old home will be also used in these rest rooms."[36]

Irrespective of these good intentions, the Gabriel Manigault House, complete with "side hall plan and side piazza" and incredibly rich Charleston provenance, came crashing down, along with, ironically, the rest of the global economy as the Great Depression got underway. Unfortunate as this loss was, it would eventually get worse.[37]

Only a few blocks away, at the corner of Calhoun and King Streets, stood the Charleston Orphan House. Founded in 1790, following a yellow fever epidemic, it was the first such public institution in the nation. The building, the cornerstone of which was laid near Boundary Street (modern-day Calhoun) by none other than President George Washington in May 1791, was completed in 1794. Twenty-five years later, it was nationally acclaimed as "the pride of Charleston," an institution where "within its walls hundreds have been matured to usefulness, many to importance, and a few to honor in the state." Major renovations in the 1850s expanded the Orphan House, its grounds soon encompassing the entire city block between King and St. Philip Streets. By the time of the Civil War, it had room to accommodate 216 children and maintained its own educational facilities. It was also during this expansion phase that *Charity*, a fourteen-foot wooden statue, was mounted atop the cupola. Despite providing food, shelter and education to the most vulnerable members of society for almost 160 years, no similar acts of kindness would be afforded to the Orphan House.[38]

Some rather critical reports from the Child Welfare League of America in 1948 marked the beginning of the end for the historic Orphan House. Two years later, after its commissioners announced they would be moving operations north of town to a thirty-seven-acre former plantation, which offered "a more home-like setting," rumors began to surface that the current urban complex was no longer considered an appropriate one for the children. If that were the case, what was to become of the property? There were alarming whispers that the site would make a fine parking lot for King Street shoppers. Others suggested a new hotel. No matter the rumors, business was sure to win out, as one letter to the editor stated: "Some selfish commercial interests will seek to obtain the orphan house property at a sacrifice price in order to demolish the building and that should never be."[39]

Regardless of public input, the newspaper confirmed that on September 26, 1950, Sears, Roebuck and Company had offered the city $350,000 for

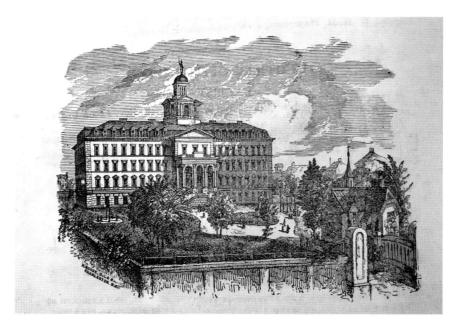

Printed image of Charleston Orphan house, as viewed from Calhoun Street. *Charleston City Directory, 1869, public domain.*

the property. Even though the transaction was at first deferred by the mayor and city council, inevitably the purchase was pushed through. Finally, on February 3, 1952, near the same spot where President Washington had witnessed the Orphan House's beginning, demolition crews ensured its end. The outbuildings went first, most notably the chapel, designed by Gabriel Manigault no less, and thus yet another of his works was lost. Not even *Charity* was spared, having "tumbled and splintered during the razing process." Today, only a portion of the statue is on display at The Charleston Museum.[40]

Demolition "in the name of progress," while admittedly necessary at times, is predictably not always the most welcomed change. Commercial endeavors, to be sure, have made massive and, occasionally, misguided impacts on the city's urban backdrop. There are, fortuitously, a few refreshing instances where a building defied the odds. At 363 King Street, an 1891 Second Empire–style building, described by its owner as a "monstrosity with no redeeming features," was saved from demolition six times between 1976 and 1977.[41]

During his 1825 Lowcountry visit, the Marquis de Lafayette wrote: "Charleston is one of the best built" places in America. Even his onetime

enemy Hessian staff captain Johann von Hinrichs was of the same mind, when, after the 1780 siege, he wrote: "No other American city can compare with Charleston in the beauty of its houses and the splendor and taste displayed therein." Noting the city's general population, he furthermore seemed amazed at "the rapid ascendancy of families" who had "contributed a good deal toward [Charleston's] grandiose display of splendor." Given their thoughts, it is doubtful whether Hinrichs or Lafayette could ever have imagined that *time* itself would eventually become a threat to the buildings of Charleston. In January 2017, despite its ongoing restorations, a lovely 1852 Greek Revival home, beautifully complemented by its Temple of the Winds portico, which faced Gadsden Street, was found to have "five separate fatal flaws." "Any one," said an on-site structural engineer, "could cause the building to collapse immediately." Regretfully, although the house ranked high on the city inventory of historically significant buildings, officials were left with no choice but to have it "torn down…before it falls down."[42]

THE CHARLESTON HOTEL

Of all the things that could have replaced the magnificently elegant, structurally dominating Charleston Hotel, a cheaply built motor lodge was probably the most insulting. Sure, the brand-new "Heart of Charleston" motel had full air conditioning, 120 rooms and a pool, but it could never hope to replace what had once proudly occupied the site. "To many Charlestonians," wrote one real estate professional, "the loss of the Charleston Hotel is on the same par as the demolition of the Orphan House." In truth, the original hotel was never meant to blend in with the city's heretofore traditional, genteel style—and that was the point right from the start. The hotel investors saw an opportunity to take advantage of Charleston's state and regional role as an economic hub, attracting those involved in finance, agriculture, mercantilism and international trade. If their hotel accommodations were luxurious enough, past loyalties to other establishments would be broken, and having once experienced this new level of splendor and service, the entire business community would flock to them in droves.[43]

Fortunately, the Charleston Hotel proprietors were not alone in their vision for the 1830s. Many of their contemporaries were still suffering the effects of the previous decade's recession and in need of whatever economic boost they could find. Thus, there began a concerted movement among the

urban businessmen to develop and present Charleston as a "Queen City…
to the south what New York is to the Union." Former mayor Elias Horry
agreed, practically preaching to the Agricultural Society of South Carolina:
"The productions of [South Carolina's] agriculture would waste on the soil
on which they grew, if there be no vent for their exportation…in a free and
liberal commerce to carry them away."[44]

Eyeing a prime spot of land on Meeting Street that, thanks to a disastrous
1835 fire, was wide open, "extensive and commodious" plans for the
new Charleston Hotel were underway within months. "No expense will
be spared," boasted its developers, "to make it one of the most splendid
establishments in the southern country." Working from a grand design by
German architect Charles Reichardt, whose local triumphs included the
Washington Race Course, Guardhouse and Charleston Theatre (all of them
now lost), a mammoth, four-story edifice with rich Greek Revival overtones
began to rise from the corner of Meeting and Market Streets. As the hotel
was nearing completion in March 1838, the backers, eager to debut "this
noble architectural ornament of our city," hosted two hundred guests in the
first-floor saloon. One journalist, recording the "festive celebration," lovingly
wrote how he "never saw such a public dinner for so large a company, so
admirably provided and conducted.…The company seemed to be very
great, and was enlivened by sparkling wit as well as sparkling wine."[45]

Indeed, it was a glowing review of what was to be, as one guest toasted,
"The first page in the history of the Hotel promises a volume of good
things." Then disaster struck.[46]

Barely a month after the party and before a single guest could check in,
another great fire tore through part of the commercial district and gutted
an adjacent residential area, destroying 1,100 buildings. The Charleston
Hotel was totally engulfed and collapsed in a heap. Undaunted, hotel
management, "in a decision that spoke to their commercial aspirations and
confidence," announced their intention to rebuild and to do so quickly. On
June 6, a "spirited meeting" took place, at which time hotel proprietors once
again reassured the public that they would "sustain their high character for
liberality and patriotism, and that the hotel will be reinstated."[47]

Utilizing Reichardt's original design as a starting point but deciding to
go even bigger, hotel management launched construction on the second
Charleston Hotel, which "raised Phoenix-like from its ashes" in 1839. Its
reconstruction was accompanied by a promise from its owners that "the
building shall be finished and completely ready for occupation on the 1st
day of August." The first hotel had definitely been impressive, but the new

one was an architectural colossus. A fourteen-column colonnade fronted Meeting Street, each pillar topped by the unmistakable Corinthian order. Inside, a lavish dining room, located in the southern end of the building, was "fitted up with lace curtains and lambrequins [draperies] and has a table with covers for eight persons, a buffet of black walnut with Marble top occupies a position against the east wall." French and German chefs offered menus of "venison, wild turkey, quail, rice birds and mallard duck." Upstairs, room 116, or the "Bridal Chamber," as the newspaper termed it, "is probably one of the prettiest parlors in any hotel in the South. It is furnished with a parlor set of rich crimson velvet, to which have been added two luxurious rocking chairs of variegated rep silk. A full length mirror stands against the south wall, and another large mirror rests on the richly carved mantelpiece, which is between the two doors in the west wall opening on the second story plaza [sic] and are curtained with lace curtains topped with rich lambrequins, The floor is covered by a heavy velvet carpet."[48]

As the 1840s and '50s progressed, business boomed at the Charleston Hotel. The South Carolina Jockey Club eagerly relocated its headquarters there. The newspaper printed weekly lists of prominent guests, who, in 1849, included President James K. Polk and, a year later, Jenny Lind, the "Swedish Nightingale," an opera superstar who, inexplicably, found Charleston a "dull and unimpassioned" place. The hotel also unwittingly became a political hub shortly after the beginning of what would prove to be the tumultuous 1860s. In April 1860, many southern delegates, furious with their own Democratic Party, abandoned its National Convention being held a mere two blocks away at South Carolina Institute Hall and proceeded to hold their own meetings at various locations, including one in the comfortable confines of the hotel saloon.[49]

The Charleston Hotel survived the Civil War but not unscathed. After being threatened but eventually bypassed by the Great Fire of 1861, the building was struck by several shells during the 1863–65 Union bombardment, forcing its closure. Following postwar repairs, the enterprise reopened, quickly resuming its status as the city's premier hostelry. In January 1883, one of Queen Victoria's daughters, Princess Louise, took up eight suites, while "the entire southern wing of the building, containing all fifteen rooms, was set apart" for the rest of her entourage. It was the first time any member of the British royal family had ever visited Charleston.[50]

Regrettably, by 1900, while the hotel may have appeared poised to take the twentieth century by storm, internal struggles and financial woes lurked behind the scenes. In 1903, the business was in serious debt, selling later in

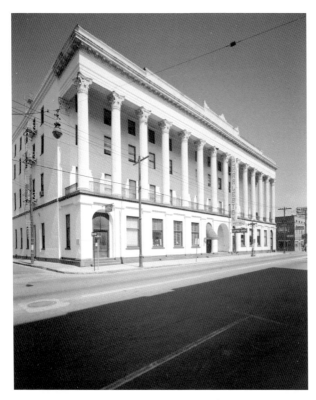

The Charleston
Hotel Meeting Street
exterior and "interior
mezzanine," 1958.
Library of Congress.

the year for $34,000. The new owners repaired and renovated much of its lower levels and lobby, installing wider corridors and stained-glass windows. State dinners for President William Howard Taft in 1909 and Vice President Calvin Coolidge in 1922 garnered much-needed publicity for both the city and the hotel, but the onset of the Great Depression all but squashed this short-lived resurgence. The owners in the 1950s reported that, of the building's 140 rentable rooms, barely half were occupied—even during peak tourist season. Some last-ditch remodeling in 1958 proved fruitless in attracting guests, and by the end of the year, the estimated cost of continued operation far outstripped the expense of merely razing the building.[51]

The venerable Charleston Hotel, "[c]ondemned to death by economic necessity," closed its doors forever on December 1, 1958, with demolition beginning just after the new year. Wrecking crews moved fast, starting at the top floor of the 150-by-420-foot property and working their way down. A large crane with a wrecking ball went to work on the columns a few days later. Within weeks, all that remained of "Charleston's last remaining links with the romantic days of terrapin soup, gas lights and visiting royalty" was a flat lot of bare earth.[52]

If nothing else, however, the loss of the Charleston Hotel was not completely in vain. Its 1959 razing seemed to rejuvenate the city's collective preservationist ideals, first espoused by Susan Pringle Frost four decades earlier. Public grumblings to enlarge the historic district grew much louder, and this time, city council was listening. With the dust from the Charleston Hotel barely settled, Charleston officials reviewed, revised and expanded the historic zoning ordinance, additionally giving the Board of Architectural Review preventative authority over demolitions.[53]

THE RADCLIFFE-KING HOUSE

The early to mid-twentieth century was, without question, the most apprehensive period for those in the preservation community, as old and historic structures were constantly under threat. Buildings were frequently demolished, for any number of forgivable, maybe even understandable, reasons. In the past, plenty of wealthy Charlestonians had built grand mansions, especially between the American Revolution and Civil War, but time was not always kind to many of them. Add to that the cost of upkeep, particularly during eras of economic depression, such as those of the 1870s

and 1930s, and many descendants of once prosperous families found it easier—and more profitable—to sell rather than restore. Furthermore, as the city sought to modernize, officials made no secret of their preference to clear lots entirely to make way for more modern enterprises, in favor of more modern structures, such as filling stations and department stores. Still, it was not as if all this change was welcomed by the locals. To quote one editorial:

> *The peevish complaint of local preservationists that much of what has been torn down in Charleston is better than what is left is not wholly without foundation. One area which has suffered from the slow but steady work of the wreckers is the old Ansonboro [sic] section of upper Meeting Street. In the late decades of the 18th century and during the early 19th, when big money was being spent on architecture, the section of Meeting Street above Market was fashionable suburbia. Since World War II the entire neighborhood has lost its character because it has lost most of its fine buildings.*[54]

Mercifully, not all was lost. Noting how Charleston by 1952 had become a swift "Dealer in Destruction," one newspaper report revealed: "A housewrecker's job is a hazardous one.…He leads a double business life, tearing down old buildings to salvage old materials which he will resell to someone interested in building a new house. He prefers to call himself a 'Dealer in Used Building Materials.'" Now, whatever feelings the article was attempting to evoke, it is not necessarily a bad thing that certain houses and buildings, when facing obliteration, still had within them redeemable architectural elements that an enterprising salvager could offer out for sale in the somewhat dubious name of preservation. Even earlier, Susan Pringle Frost and her preservation contemporaries had had to face the reality that an all-or-nothing approach to saving historic structures was, at times, impractical. When dilapidated or unstable old buildings were slated for demolition, Frost and her cohorts diligently recovered assorted architectural bits and pieces with the hope of reinstallation elsewhere. In other words, since they could not save it all, they saved what they could.[55]

In this vein, the monumental three-story Radcliffe-King House, which once commanded the northwest corner of Meeting and George Streets, while still a tremendous architectural loss, should not be considered a complete one.

Near the end of the eighteenth century, merchant Thomas Radcliffe wasted little time in establishing himself as one of the shrewder property barons on the Charleston peninsula, purchasing, surveying and ultimately developing a large section of unimproved land north of present-day Calhoun Street. Unsurprisingly, the choicest tract of his extensive holdings he reserved for himself and his wife, Lucretia, where the couple built one of the finest mansions ever seen in the city.

Completed in 1806, the impressive Federal-style home was certainly on a par with that of the Radcliffes' neighbors to the north, Joseph and Charlotte Drayton Manigault, whose 1803 house was—and still is—an architectural marvel. Recalling one of the lavish parties hosted by the Radcliffes, within their "celebrated mansion house in the city," one Manigault wrote in 1809:

> *The stair case is very pretty, and the passage above remarkably large and well finished. It was furnished with handsome girandoles* [branched candleholders], *& ornamented with festoons of flowers, & flower pots from her green house shedding fragrant odours* [sic]. *The drawing room retained its carpet and card tables were ready to accommodate those who did not prefer dancing…Hers was a complete Ball—for it concluded with a magnificent supper at which near eighty persons were seated.*[56]

Sadly, Thomas had precious little time to enjoy his magnificent residence (and the soirees therein) before being lost at sea just months after his home was finished. Lucretia carried on her husband's work, continuing to develop her extensive properties. In 1811, she donated four lots for the construction of the Third Episcopal Church, now the site of the Cathedral of St. Luke and St. Paul on Coming Street, within the aptly named Radcliffeborough neighborhood.

Remaining in the house until her death and having never written a will to "detail the distribution of her estate," Lucretia left the disposition of her house and all other properties to the discretion of court-appointed executors. After most of her furniture and other possessions were auctioned off in 1821, the house quickly sold. It was purchased by Mitchell King, a prominent Charleston attorney and future city court judge, but a man with a reputation for having "gained great wealth by marrying two heiresses." Born in Scotland and resident in Charleston one year prior to Thomas's death, King nobly carried on the Radcliffe tradition of hospitality, regularly entertaining "in grand style." Alas, King's death in 1862 was perhaps the beginning of a long, slow decline for the regal home. His family did its

best to maintain the residence amid a dismal, decades-long post–Civil War depression. In 1880, anticipating a state legislative act that would divide the city into six school districts, Charleston City Council brokered a deal to purchase the King property for just under $12,000. Council spent an additional $4,000 on "repairs and changes to adapt the structure for educational use" and, when complete, had transformed the Radcliffe-King House into the High School of Charleston.[57]

According to one newspaper report, the school was, for a time, "one of the most flourishing institutions of the city." Enrollment reached 160 students, and within three years, the school employed seven teachers. By 1921, because of the school's academic reputation, it was fast running out of room. Over 900 pupils were crammed into its one-acre property, and "the location of the building in close juxtaposition to private homes must constitute a real annoyance to both school and homes....It is clear that even with excessive expenditures this center cannot be considered the desirable location."[58]

With that, the fate of the once prominent and unquestionably stately Radcliffe-King House was forever sealed. In 1934, word of the school's relocation to a larger campus spread rapidly. The College of Charleston, the school's next-door neighbor, eyed the property acquisitively as a prospective location for its gymnasium.

Obviously, the school's architectural changes between the 1880s and 1930s, while considerable, were insufficient to accommodate such a drastic remodel. Decades of wear and tear from the many comings and goings of countless adolescents had all but compromised the building's cosmetic and structural integrity. By 1938, in the absence of any miraculous—and surely expensive—solution, city officials decided that the house had to go. At first, a few local preservation leaders launched some ambitious efforts to save the house and grounds in their entirety. Charleston Museum director Laura Bragg even petitioned the Carnegie Foundation to purchase the house and use it as a Charleston satellite office. Her endeavor failed, but at the very least, it did succeed in causing a preservation stir.[59]

Fortunately, College of Charleston trustees, with help from several government officials, understanding that yet another part of city history was about to be condemned and destroyed, secured federal funding to hire one of their own to advocate for a more measured tear-down instead of another calamitous demolition. Never one to sit idly by in the midst of a crisis, esteemed local architect Albert Simons, a lifelong Charlestonian and one well versed in the city's historic character, vitality and conservancy, agreed to

design the new gymnasium, saving what he could of the doomed mansion. In the mid-1930s, Simons enlisted his business partner Samuel Lapham, Laura Bragg and numerous others of the preservation community to assist him in his elaborate and backbreaking plan. This small but dedicated group of preservationists took to removing key elements from both the interior and exterior of the Radcliffe-King House, all to be saved, stored and, hopefully, reinstalled elsewhere. They salvaged wainscoting, various woodwork, window and door surrounds, mantels, mahogany doors and plasterworks. They took down much larger features, too, including the staircase and nearly all the perimeter ironwork.[60]

Eventually, pieces and parts of the former Radcliffe-King House made their way into other restoration endeavors, not the least of which was the 1935–37 Dock Street Theatre project. Obtaining federal funds through the Works Progress Administration in 1934, Mayor Burnet Rhett Maybank, with input from "various organizations interested in Charleston's historical and artistic development," decided that the

Elements of the destroyed Radcliffe-King House, including the door surround and mantelpiece shown here, which were incorporated into the Dock Street Theatre interior during renovations in the 1930s. *Library of Congress.*

Above: Wrought-iron fencing from the destroyed Radcliffe-King House was saved and reinstalled directly across George Street at the Washington Light Infantry armory. *Author's photo*.

Opposite: The Radcliffe-King House, as seen from the George Street entrance. *Library of Congress*.

section of Church Street near St. Philip's Church, "which contained many historical landmarks in a state of disrepair and ruin, would be an appropriate area for restorational efforts."[61]

As expected, demolition crews made quick work of the Radcliffe-King House on October 27, 1937. However, many significant artistic components are still around—assuming one knows where to look. The Charleston Museum retains several exterior column capitals. At the Dock Street, "Palladian windows, scrolled plasterwork, and intricate carvings of flora and figures" adorn various rooms. Several house mantelpieces, installed in the theater's green room, exhibit impressively formed "biblical scenes, angelic figures, and draped floral embellishments." The ironwork, befittingly, remained closer to its original location. Most of it was reinstalled right across the street and today borders the north and east sides of the Washington Light Infantry armory.[62]

THE NATHANIEL HEYWARD HOUSE

A touching, yet telling, phrase is handwritten on the reverse side of an old photo of the Nathaniel Heyward House on East Bay Street: "A memory now, pulled down & gone, but as beautiful a house as one was ever in, all paneled and carved."[63]

If not South Carolina's most productive rice planter, then surely its richest, Nathaniel Heyward exploited the specialized knowledge of his many slaves and developed the far more cost-effective system of "tidal" rice cultivation. That is, by utilizing earthen barriers—ditches, dikes and levees—rice fields could be kept separated from the adjacent river. Large wooden rice trunks (or "gates") controlled the regular tidal flow into and out of the fields. Needless to say, this system was incredibly hard on the enslaved men and women charged with its implementation and operation. For Heyward, on the other hand, the technique produced upward of 1,500 pounds of rice per acre, instead of the average 800-pound yields harvested from stagnant inland swamps. With the proliferation of the tidal flooding system, Heyward and his fellow rice planters—and, of course, their enslaved laborers—revitalized the post-Revolution Charleston economy.[64]

Only adding to Heyward's practically uncountable fortunes was his February 1788 marriage to Henrietta Manigault. Their wedding effectively united two of the wealthiest families in the southern half of the new nation. It is believed that, upon his death in April 1851, Heyward owned upward of thirty-five thousand acres, spread out over a whopping twenty-three separate Lowcountry plantations. Add to that the thousands of slaves he owned over the course of his lifetime (around two thousand were listed in his estate records), and Nathaniel Heyward was, in all probability, "the wealthiest man in antebellum South Carolina."[65]

In town, Nathaniel Heyward owned or co-owned multiple properties, some sources indicating, at one time, no fewer than nine. A few he passed around to relatives. In 1803, for example, he sold a large lot at present-day 18 Meeting Street to his half brother and Declaration of Independence signer Thomas Heyward Jr., who built a lovely three-story single house on the property that still stands today. Nathaniel must have favored the house, because he paid a princely sum of $20,000 to buy it several years after Thomas's death. Previously, around the same time as his marriage, Heyward, still in his early twenties, built what was probably his first urban residence on the corner of East Bay and Society Streets. Described as a wooden-frame "T-shaped structure with handsome octagonal rooms at each

end," its towering portico was symmetrically positioned behind handsome gates that faced East Bay Street, each flanked by brick pillars topped with stone, urn-shaped finials.[66]

Despite its wooden construction, Heyward's stately home, one of the very few large ones built on East Bay Street during the period, served the master planter well—or at least whenever he was in town for business or social occasions. Certainly not the grandest urban dwelling at the time, it did not need to be, because it was not Heyward's principal residence. With almost two dozen other properties throughout the state's coastal regions, it remains unclear just how much time he actually spent there. There are no indications that the house was occupied at all when it barely escaped the disastrous Great Fire of 1838, which consumed the properties of several dozen close neighbors.[67]

Although clearly a brilliant businessman and canny investor, Nathaniel Heyward never could have predicted the deleterious effects that industrialization between East Bay Street and the nearby banks of the Cooper River would have on his the fate of his house. For the remainder of the nineteenth century, the "approach of business establishment[s],"

The Nathaniel Heyward House, as seen from East Bay Street, circa 1912. *Courtesy of The Charleston Museum, Charleston, South Carolina.*

including warehouses and wharves, spread expansively up and down the riverside. There was even worse news by 1915. Right across the street, Charleston had finally landed a deal with the Seaboard Air Line Railway, which announced, on August 10, its intentions "to make this port one of its main stations." As construction on the railroad facilities got underway, one of the last occupants of Heyward's former house, Mary O. Marshall, who was born there, vacated the property for good, but not before removing several of Heyward's original mantels. She later installed at least one of them on the second-floor drawing room of her new Church Street home, today known as the George Eveleigh House.[68]

With the house empty, it was only a matter of time. Sure enough, in the winter of 1917, the newspaper publicized a "Master's Auction," which aimed to sell and divide miscellaneous lots along East Bay and Society Streets, including the site "formerly belonging to Nathaniel Heyward." Ultimately "pulled down" that same year, "the demolishing of the Nathaniel Heyward House…and the removal of the stone caps on the top of the gate posts leaves Bay Street stripped," wrote one observer. Its surrounding grounds were subdivided into modest-sized rental properties, "the small portion of it remaining [carries] no resemblance to the former dwelling.…It is only reasonable that every house cannot be saved—it is not reasonable, however, to destroy residential areas which a little care and forethought might save."[69]

3

LEFT FOR DEAD

Understanding the breadth of Charleston's past, city planners encourage contractors to make allowances for delays and set aside additional funds for the possibility that their construction projects might encounter what are euphemistically called "unexpected discoveries." It's an intentionally vague term and one that smartly covers just about every eventuality. Indeed, wherever construction occurs in a city as old as Charleston, be it near a college campus, a municipal building, a church or even a private home, the likelihood of unearthing a few long-lost remnants is understandable, nay, expected. An iron fragment here or a pottery sherd there each serves as an interesting reminder of a citizenry that once was. [70]

Occasionally, these same projects can uncover those very citizens themselves.

Bulldozers working to clear land on James Island in 1996 had not been running long before the first few bones were churned up. The grisly revelation brought site preparation for a new city fire station near McLeod Plantation to a screeching halt. In all, almost one hundred heretofore unknown graves were discovered, prompting some careful and immediate research of the surrounding area. This examination, coupled with dutiful studies of the remains, soon revealed the site as a long-forgotten and unrecorded cemetery for, among others, the many slaves who worked in the McLeod house and fields throughout the first half of the nineteenth century. The fire station was appropriately relocated to another site on Folly Road, and the lot was preserved as a memorial garden: "In honor of all the Africans brought to the Lowcountry against their will."[71]

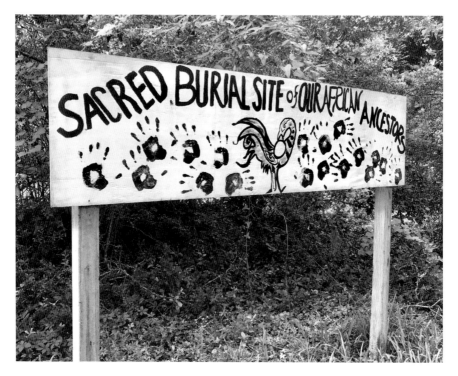

A hand-painted wooden sign marks the border of an African American cemetery discovered adjacent to McLeod Plantation. The site is now preserved as a historic cemetery by Charleston County Parks. *Author's photo.*

This James Island example was hardly the first discovery of lost burial grounds in and around the city and, most certainly, will not be the last. Unmapped and otherwise forgotten burial plots and cemeteries, while perhaps morose to discuss, are undeniably present throughout the area, and when one is discovered (accidentally or not) an entirely new chapter in South Carolina's Lowcountry history can be written.

PUBLIC CEMETERIES AND THE "OLD BURIAL PLACE"

It is strangely humorous that the first local mention of an "old burial place" came in 1698, since peninsular settlement was not even twenty years old at the time. Whatever the reason for the modifier, though, clearly early on

a large and, more importantly, *public* cemetery was much needed. Church graveyards were obviously present, but most were reserved exclusively for members of the respective congregations. Families occasionally utilized sections of their own private property as burial grounds for their kinfolk, a practice that, although not recommended, was not against the law at the time. So what about everyone else?[72]

Francis Nicholson, South Carolina's first royal governor, may very well have asked that same question after his 1721 arrival in Charleston. Disgusted by the sheer number of unclaimed bodies—sailors, transients and slaves, among others—he described how many were "promiscuously buried in lots and some in the streets." He put forth an urgent recommendation to the Commons House of Assembly to formulate a solution and set some official borders around the extant but unofficial "Old Burial Place," a once vacant field north of present-day Beaufain Street. Even though it took three years, surveyors had measured out a precise four-acre block, which included the already existing cemetery, a space bounded today by Franklin, Magazine, Logan and Queen Streets.[73]

This "new" public cemetery served the city well, at least for a while. By 1768, however, it too was overfilled and the Board of Police had to work expeditiously to establish yet another new burial ground adjacent to the "old" one, with a separate area for slaves. Opened just before 1769, it lasted less than twenty-five years before reaching capacity. In 1792, as the dead continued to overwhelm all the places to put them, city council was yet again seeking another public interment site, stating, on August 20, that it was urgently "necessary that a place be appropriated for the burial of strangers, those who may die in the poor house, hospitals, and negroes." Concerned as well was Charleston's Medical Society, which further recommended to city councilmen that, to "greatly conduce to the health" of Charlestonians everywhere, "a sufficient piece of ground should be procured without [outside] the city and enclosed for a public burial ground."[74]

It is no surprise that those living within the city would cite medical concerns. Epidemics—smallpox and yellow fever, especially—were among the main reasons that Charleston's public cemeteries filled so quickly. Smallpox ravaged the peninsula beginning in the mid-eighteenth century. In 1760, it was estimated to have infected upward of six thousand residents (roughly 75 percent of Charleston's population), killing about one in eight. Yellow fever took its toll as well. Charleston physician Dr. Alexander Hewat described one such outbreak in the 1720s as "so general that few can grant assistance to their distressed neighbors....So many funerals happening each

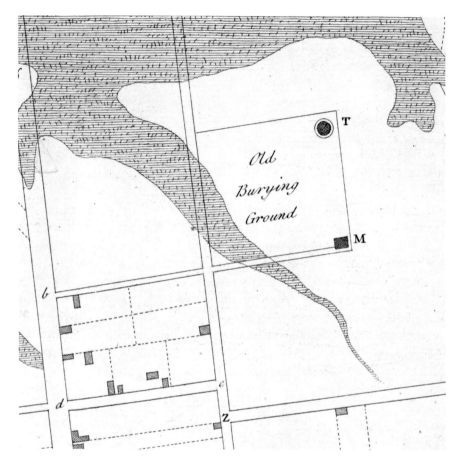

Detail of "The Ichnography of Charles-Towne, at High Water," 1739, showing
Charleston's "Old Burying Ground" (referred to occasionally in period documents as the
"Old Burial Place"), near the present-day corner of Franklin and Queen Streets. *Map
reproduction courtesy of the Norman B. Leventhal Map Center at the Boston Public Library, public domain.*

day, while so many lay sick, persons sufficient for burying the dead are
scarcely to be found…so quick is the putrification, so offensive and infectious
are the corpses, that even the nearest family relations seem averse from the
necessary duty."[75]

As alluded to by Hewat, in addition to the sheer numbers of dead, there
also was the disquieting belief that each and every one of their corpses
was carrying—and could still spread—whatever disease had killed them.
Consequently, all new cemeteries were going to have to be outside city limits
for the sake of public safety. It made sense at the time, but what Charlestonians

could not have foreseen was just how far and how inexorably the city would expand its borders over the course of several generations. As this process proceeded, what were once undesirable burial grounds outside the city soon became valuable and much-needed real estate *within* it, and whatever concern the local citizenry might have had for those nameless, unclaimed and unchurched bodies, all within Charleston's scattered public cemeteries, waned considerably. Thus, public burial grounds of the lower social classes were perceived as not nearly as important—or sacred—as those affiliated with well-to-do church properties. So, as Charleston mayor Henry Pinckney queried in 1839, "What becomes of the repose of the dead?"[76]

His concern, apparently, mattered little. City officials had no trouble decommissioning the properties, subdividing them and then selling off individual lots. This was a regretfully ignominious dispersal of land to be sure and one that soon gave rise to new houses and new neighborhoods.

Today, more than a few burial grounds remain lost to history—and frankly, even one is too many. For some, fortunately, there still exist several old maps and plats that record their general locations, but for most, it is by pure accident that these once known (and well-used) cemeteries are rediscovered.

Still, as one local newspaper succinctly admitted: "It's not unusual to find forgotten graves in this area." Road and building construction tends, all too often, to unearth long-forgotten gravesites. In March 2017, construction crews working near Burke High School's Harmon Field, on Fishburne Street, unearthed upward of fifteen sets of remains, all of them buried in a city-operated paupers' field during early 1800s. Just down the block, scheduled renovations to The Citadel's Johnson-Hagood football stadium were put on hold while archaeologists uncovered, exhumed and relocated 341 graves, including several dozen Confederate war dead. In all likelihood, this was "the largest forgotten cemetery in the city's history." Ostensibly, its occupants had been relocated before the city began building the stadium in 1948. In what one hopes was an unfortunate misunderstanding but may well have been an act of expediency and indifference, the work crews removed *only* the headstones.[77]

Elizabeth Hutchinson Jackson

In 1825, President Andrew Jackson received a letter from his friend and former Lancaster County, South Carolina neighbor James H. Witherspoon.

Though forty-four years had passed and despite some reasonably reliable hearsay, no one really knew where Jackson's mother was buried. "Your Mother," Witherspoon wrote, "was buried in the suburbs of Charleston, about one mile from what was then called the Governor's Gate, which is in and about the forks of the Meeting and Kingstree Roads." For Jackson, it was as close as he would ever get to locating her lost remains. [78]

In 1781, Andrew was barely a teenager when his mother, Elizabeth Hutchinson Jackson, left him at home in the thick of the Revolutionary War. Having already lost two sons to the conflict (with Andrew coming close to death himself), she considered it her duty to travel to Charleston and provide care for members of her extended family. A pair of ill nephews needed tending, as did hundreds of American soldiers being held captive by the occupying British. For all her compassion, unfortunately, nothing could save her from the rampant diseases that infected the prison ships she served on. Taken ill, she died on November 2, 1781, and was unceremoniously buried in an unmarked grave a few miles north of town. [79]

Jackson brooded over his mother's missing remains for the rest of his life, wishing "only [to] collect her bones and inter them with that of my father and brothers" at the Old Waxhaw Presbyterian Church cemetery near his birthplace in Lancaster County. [80]

Tragically, the mortal traces of Elizabeth Hutchinson Jackson's body are still lost somewhere in Charleston soil. Perhaps a best guess would be near the corner of today's Heriot Street and King Street Extension, but a century-old railroad track running over the top of this location creates a rather formidable barrier to any sort of archaeological recovery. Not even her memorial stone, placed "near this spot" in the early 1940s, is there anymore. First erected in 1942, it soon fell into disrepair, developing some aggressive cracks and a noticeable list to one side. Weeds and water were a problem, too. A new granite base was installed in 1947, but its deterioration continued unabated. In 1955, fully aware of the marker's plight, the Daughters of the American Revolution requested permission to move it to a more visible part of town but were denied by the marker's original funders. [81]

Finally, in 1967, an association of civic groups and a few local historians successfully appealed for the marker's relocation to the College of Charleston, placing it near the center of campus. Alas, within a few years, dense shrubbery rendered it all but invisible. This natural cover remained until 2005, when grounds beautification exposed it once more.

Of course, with the stone moved to the college campus, much of the context is just as lost as Elizabeth Jackson's mortal remains. With no additional text

NEAR THIS SPOT IS BURIED,
ELIZABETH JACKSON,
MOTHER OF PRESIDENT ANDREW JACKSON,
SHE GAVE HER LIFE CHEERFULLY FOR
THE INDEPENDENCE OF HER COUNTRY,
ON AN UNRECORDED DATE IN NOV. 1781,
AND TO HER SON ANDY THIS ADVICE:
"ANDY, NEVER TELL A LIE,
NOR TAKE WHAT IS NOT YOUR OWN,
NOR SUE FOR SLANDER,
SETTLE THOSE CASES YOURSELF"

The Elizabeth Hutchinson Jackson memorial marker now stands near the center of the College of Charleston campus, just off Calhoun Street. *Author's photo.*

to indicate the marker's original location, those who take the time to read it assume that Mrs. Jackson is buried nearby. As one local journalist pointed out, "99.99 percent of the College of Charleston's students and faculty walk by a memorial to the mother of President Andrew Jackson every day with no clue about how wrong it is."[82]

THE QUAKER GRAVEYARD

Stating that "the county has no alternative site at this point," local government officials in 1969 instructed workers to begin clearing land at the corner of King and Queen Streets. At first, the work affected only small sections of the land upon which Charleston's two Quaker meetinghouses had once stood. But engineers had already made eminently clear that even larger portions would soon be needed "in connection with the construction of the county's $1 million high-rise parking garage."[83]

Fortunately, getting rid of the two meetinghouses was not a problem. An 1838 fire had destroyed the original 1731 wooden building. In 1861, a mere five years after the Society of the Friends in Philadelphia had reestablished a second Quaker meetinghouse, "fronting 25 feet by 35 feet in depth" along King Street, another fire, this one the largest the city had ever seen, engulfed it in minutes, along with hundreds of other Charleston buildings. With both buildings long gone, the only legacy of the Quakers' presence

Detail of "Ichnography of Charleston, South-Carolina: at the request of Adam Tunno, Esq., for the use of the Phoenix Fire-Company of London, taken from actual survey, 2d August 1788," showing the Quaker meetinghouse (marked "Q") and its adjacent burial ground, near the present-day corner of King and Queen Streets. *Library of Congress, Geography and Map Division.*

was their graveyard, the markers of which stood alone within an otherwise vacant lot, surrounded by a few houses on the north and south sides and the Mills House Hotel along its eastern border. By 1918, only two grave markers remained, the others having been lost to the elements. Despite this, the lot itself was somehow "preserved with reverential care."[84]

The solemn survival of the Quaker burial ground came to an end in 1968. The Society of the Friends in Philadelphia, seeing no practical need for its continued preservation, "concurred with the county's plan to use the site for a parking garage, with provisions for relocating the burials." Gaining final approval, the city soon focused in on what it deemed "the most delicate detail" and worked carefully to exhume all nineteen bodies that were found (though many more likely went undiscovered). A few were reinterred within the same property boundaries, but others were removed to a small green space adjacent to the O.T. Wallace County Office Building, near the intersection of Meeting and Broad Streets. Following completion of the garage, on October 28, 1970, the Preservation Society placed a historic marker facing King Street.[85]

THE GAILLARD PERFORMANCE HALL

"All these years I've been doing this, I've never found a body before," said one construction worker involved in the 2013 renovation of the city-owned Gaillard Performance Hall, Charleston's largest performing arts venue. For him, that all changed on February 5, 2013, when his track hoe, in the process of digging a six-foot drainage trench near the corner of Anson and George Streets, exposed a skull. A short distance away, others workers found more remains. Before the day was out, as multiple skeletons had now been revealed, police had secured the site as a possible crime scene.[86]

The next morning, careful examination by county coroner personnel soon determined that these, whoever they might be, were not recent arrivals. Following protocol, the Coroner's Office recommended that the city contract with archaeologists to figure out the remains' identities. After all, up until the previous day's discovery, "no indication in any of the deeds, grants, or maps reviewed to date" suggested that anything even remotely resembling a cemetery had ever existed near this spot. Certainly nothing—or no one—had been unearthed back in 1968, when the Gaillard Auditorium was first constructed. Even more baffling, period

maps and plats of the area show that, not only had it been subdivided in 1798 but also at least one house already stood there as early as the 1760s. One archaeologist hypothesized that the folks living close by either "didn't know the graves were there…or didn't care." By the first quarter of the nineteenth century, practically an entire neighborhood surrounded the site, with nary a recorded peep from its inhabitants about a cemetery in their backyard. Nevertheless, by the time archeologists and licensed funeral directors had finished their work on March 1, thirty-seven graves, containing mostly adults, but a few juveniles and one infant, had been exposed, painting a rather clear picture of a "larger and more formal graveyard."[87]

As word spread of the fascinating find and the careful removal and study of the remains, it seemed everyone in Charleston was asking the same question: Who were these people? Archaeologists were quick to notice that, as the plots were uncovered one by one, each had been purposely arranged head to toe and "facing east, aligning with the Christian belief of positioning the dead so they can rise and receive the second coming of Christ." This observation furthermore concluded that this was "a deliberate cemetery where the deceased were interred over a period of time rather than a mass grave due to a sudden epidemic or catastrophe." At least one body had been placed in a coffin, as evidenced by the recovery of iron nails. Many others, based on the fragmentary evidence of brass pins, were wrapped only in shrouds. Archaeologists further noted that some had belongings buried with them, including coins and buttons (likely from their grave clothes).[88]

In the end, it was these material possessions that helped shed at least a little light on the mystery. A few of them dated to the Revolutionary War period, including a George III copper halfpenny minted in 1773. Even better, archaeologists recovered a "round stone bead," not common to the region but easily "attributed to West African culture" and, more importantly, comparable to those found in South Carolina's African cemeteries and elsewhere. As for the remains themselves, two skulls exhibited filed incisor teeth, a fascinating detail typically linked to coming-of-age or "celebration of life" observances in some West African tribes. Additional skeletal analyses and other morphological studies "confirmed black ancestry for all individuals." Finally, and perhaps far more telling, many remains showed strong "evidence of muscle tears and joint wear," consistent with sustained manual labor.[89]

In other words, they were slaves.

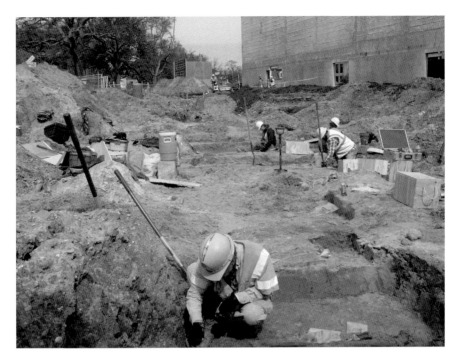

Archaeologists exhuming human remains at the Gaillard Center, 2013. *Courtesy of Brockington & Associates.*

Unfortunately, for all that *is* known about these men, women and children buried anonymously so long ago, there is still much to be learned. These remains, perhaps, could have been studied much earlier. There were, according to the 2013 data, signs of disturbance and truncation around several graves, likely coinciding with the original 1968 Gaillard project. Why was this discovery unreported? To date, it remains a mystery. The search for more answers continues through historic, biologic and forensic investigations, but this work is respectful, and everyone involved is mindful of the need to eventually return these nameless people to a hopefully final resting place.[90]

4

EARTH, WIND, FIRE, WATER

War certainly took its fair toll on Charleston. Yet even the destruction wrought by the two major conflicts on American soil could not compare with the damages and losses inflicted by the vicissitudes of nature. And once, even the solid ground beneath the residents' feet gave way. Add to that human-caused mishaps—mostly fires—and the sheer task of itemizing what Charleston lost is, in a word, overwhelming. A list of missing buildings alone would be far too lengthy for one book.

Perhaps the worst part about Lowcountry disasters is how quickly they destroyed so much of Charleston's architectural legacy. Citizens rebuilt, of course, but with each generation came changes in taste and style, which altered many a structure's original appearance, both inside and out. Seldom was a home or public building reconstituted in the exact same fashion as its earlier incarnation—if rebuilt at all.

Sometimes, historic structures are incrementally weakened by natural disasters, only succumbing decades later. Standing, somehow, in situ on South Carolina Ports Authority property, a fragile vestige of one of Charleston's once prominent rice mills still overlooks the city's Union Pier Terminal on the Cooper River. Commissioned by former governor Thomas Bennett Jr. in 1844 and constructed one year later, the small but efficient steam-powered mill, at its peak, turned out upward of two hundred bushels per day. In addition to its functionality, it was an architecturally beautiful structure, built in a "kaleidoscopic tapestry" of Classical Revival styles. After the Civil War, rice cultivation never returned to its earlier levels of production. The Bennett

family, who owned the building until 1911, refitted it for other commercial uses, with only limited success. In 1938, a tornado ripped its roof off, leading to accelerated deterioration. After it was condemned in 1952, two separate preservation organizations, the Preservation Society of Charleston and Historic Charleston Foundation, endeavored to save it. Tragically, in 1960, just as a preservation agreement was reached, Hurricane Donna swept across the city, sparing only the mill's fragmented façade.[91]

Conversely, even though some of the building materials from the Circular Congregational Church's predecessors did survive, identifying them is a difficult matter. Founded in 1681 and among the longest-tenured congregations in the South, the church meets in the building used by present-day worshippers at 150 Meeting Street, not the first or even second to occupy the site. The first was described as little more than "an old white meeting house." The building was enlarged in 1732 and refurbished in 1782 following damage by occupying British forces. In 1806, it was intentionally replaced with a grand, Robert Mills–designed structure, complete with a domed roof and the first "auditorium style" sanctuary in the nation. The church and its 182-foot steeple (added in 1838) dominated Meeting Street until gutted by fire on December 11, 1861.[92]

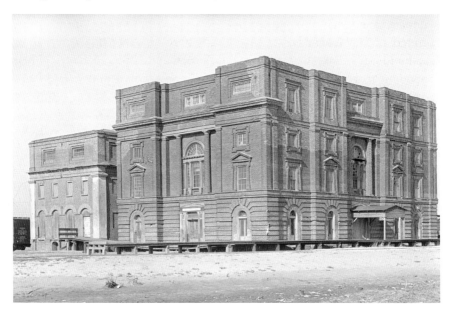

Bennett Rice Mill, 1934. *Library of Congress.*

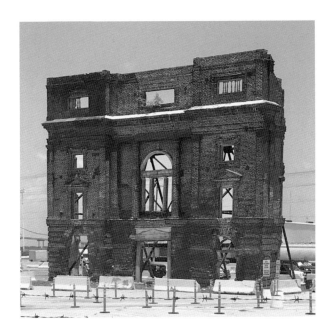

Bennett Rice Mill ruin
as it appears today.
Author's photo.

The Circular Church was not the only building consumed by flames on that fateful night. Ten days later, after completing an audit of the city's fire damage, one local newspaper, under the title "The Great Fire of 1861," printed its "Full List of Losses." Reviewing street by street, it recorded almost six hundred homes, five churches and numerous other public buildings, including South Carolina Institute Hall, where state delegates had gathered almost exactly one year earlier to sign the Ordinance of Secession. By no means was this Charleston's first major conflagration. Fires were a constant problem from the very beginning, and there was little that the authorities could do to prevent them, no matter what zany decrees they might come up with. As one visitor noted in 1764, "There is a Law against building houses of Wood, which like other Laws in other Countries no body observes." Consequently, the city burned—repeatedly. A February 1788 fire engulfed the State House at Meeting and Broad Streets. Serial arsonists wreaked havoc throughout town in 1825 and 1826, and a dangerous run of fires—fourteen in all—occurred almost every year from 1833 through 1839.[93]

Sometimes just combating a fire resulted in spectacular losses. With so many wooden structures placed so closely together on the peninsula, firefighters occasionally detonated kegs of gunpowder to clear properties and create neighborhood-saving firebreaks. The twentieth-century loss of their graveyard was not the first indignity suffered by the Quakers. Their first

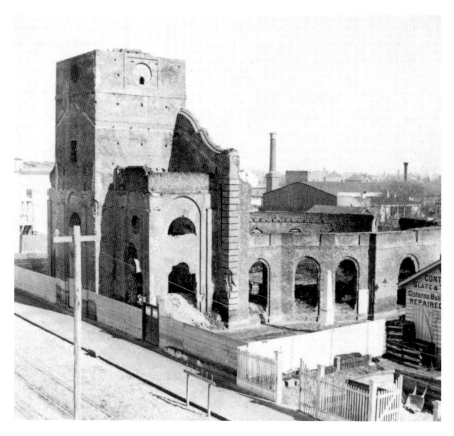

Ruins of the Circular Congregational Church after the Great Fire of 1861. *Library of Congress.*

meetinghouse was blasted to bits in the previous century. Though stopping short of accusing firefighters of negligence—or stupidity—one journalist, writing after the 1838 event, was still quick to point out that, had a different building across the street been flattened, "while the fire was yet two houses from it…the Quaker meeting house, which has so long lifted its modest little head among us, would have been saved." [94]

As for the charred ruins of the Circular Church, they stood for almost another quarter century, until an altogether different misfortune—a major earthquake—devastated the city on August 31, 1886. In the nighttime, it shook Charleston "from centre to circumference." Alas, the Circular's remaining brick walls tumbled down into a sad heap. Undaunted, congregants soon salvaged whatever loose bricks they could and, by 1890, had reincorporated many of them into the Victorian Romanesque structure one sees today. [95]

Modern residents of Charleston cannot (and for safety's sake, should not) regard local disasters, natural or otherwise, as historic occurrences of some bygone era. These same threats exist today as they have for hundreds of years. Hurricanes are most assuredly not novelties. Fires still happen. The potential for serious earthquakes must also be acknowledged. In truth, South Carolina averages between ten and fifteen earthquakes every year but—so far, at least—nearly all have been low magnitude and categorized as "not noticeable."[96]

When it comes to water, though, Charlestonians have been fighting that threat since colonial times. Despite seeking solutions to their vulnerabilities, it is a battle they have frequently lost. From storms particularly, they tried their best to "secure" the city's eastern, western and southern waterfronts. As early as 1700, legislators were looking "to prevent the sea's further encroachment," noting that it "hath undermined and broken down more of the bank bounding upon the Cooper river…and will probably in a few years (if timely care be not taken) break down and carry away all the remaining wharfs, with the houses next." However, sporadic hurricanes and their accompanying storm surges washed away many of these safeguarding barriers, along with entire sections of town. One major storm that made landfall in September 1784 "came rolling on with great impetuosity," remembered one survivor.

> *The streets were almost instantly covered with boats, boards, and wrecks of houses.…The consternation which seized the inhabitants, exceeds all description. Finding themselves amidst of a tempestuous sea, and expecting the tide to flow till one o'clock, they retired at eleven, to the upper stories of their houses, and contemplated a speedy termination of their lives.*[97]

As previously mentioned, nothing has changed, and modern-day Charlestonians share the same concerns as their predecessors. In early 2017, for instance, Charleston City Council had virtually no choice but to halt all property development within the Church Creek drainage basin, an area west of the Ashley River that for decades had been indiscriminately built upon. New neighborhoods and roads to connect them were created willy-nilly, each one filling in more and more of the basin's natural wetlands. In the summer of 2015, time ran out for any possibility of addressing these deficiencies. Heavy rain that August flooded many streets, forcing residents from their homes. Two months later, even heavier rains caused more flooding and evacuations. By January 2017, high water had damaged dozens of homes, some "for the fourth time in three years."[98]

THE SANTEE-COOPER PROJECT

Tucked away on page sixteen of a July 8, 1940 newspaper, an announcement, while not coming as a shock to anyone, still ushered in a mixture of unrest and apprehension around the Lowcountry. Government-sponsored damming of the Santee and Cooper Rivers and the eventual flooding of tens of thousands of acres would begin by the following February. At last, the "Santee Cooper project," launched as a rural electrification venture and labeled by some as the "most portentous undertaking since the Confederate War," was reaching its final stage.[99]

Named for the two rivers that would soon power its hydroelectric plants, Santee-Cooper, "a project which may alter the Life of South Carolina," one report read, was by then an undertaking two decades in the making. Discussion about how to bring much-needed electricity to the state's more isolated regions had been going on since 1917; despite that, seventeen years later, only a few thousand of the nearly 170,000 farms across South Carolina were electrified. For the families working them, "[T]he 1930s could have just as easily been the 1830s." They "went to bed with the chickens." Fortuitously, Roosevelt's New Deal set about to change all of that, and state politicians soon embraced the long-awaited electrification plan, which would get farm communities out of their economic rut.[100]

What would become South Carolina's single most expensive Depression-era enterprise had at its core two basic objectives: First of all, the reclamation, resurrection and reactivation of the old Santee Canal, which, until its closure in 1850, had provided an important water thoroughfare for transporting Upcountry plantation crops to coastal ports. One of America's first major inland navigation projects, it greatly encouraged the expansion of South Carolina's agricultural economy in the early nineteenth century. Unfortunately, rising construction costs and ongoing maintenance problems hindered canal operations almost from the moment of its opening. During droughts, for example, water levels were oftentimes too low to accommodate even shallow-draft vessels. Finally, in the 1840s, railroad construction from Charleston to Columbia and Camden rendered it obsolete.[101]

Santee-Cooper's second, far more vital objective was, at least on paper, to provide "cheap power to restore prosperity to a state in agricultural doldrums." Of course, making that happen would be a titanic enterprise, unprecedented in both size and scope. Multiple dams, thirty miles of dikes and one canal lock (when complete, the tallest in the world) were planned. Power turbines and generators were to be designed, constructed,

installed and activated. To supply the necessary water, two reservoirs had to be created. Together, they would inundate a surface area of more than 177,000 acres. It was this last detail, the eventual creation of lakes Marion and Moultrie, that had many residents within these soon-to-be-submerged regions particularly concerned.[102]

While South Carolina officials were envisioning industrial progress, they seemed to have little regard for historic context and preservation. Significant plantations, churches and cemeteries stood in the way. Even worse, many newspapers conveniently glossed over any discussion of how entire communities, whose residents had lived and worked on the land for generations, would soon be covered over with millions of gallons of water and effectively wiped off the map. Opined one Charleston journalist in 1939:

> *Everywhere in the Lowcountry people were talking about this thing that had come to disturb the placid existence of this part of the South. There were many problems that the citizens had not considered....There was the question of flooding historic battlefields, cemeteries and ancient plantations built by the French Huguenots....There were many other questions in the minds of Lowcountry citizens, but above them all hovered the possibility that life in South Carolina might be changed. There were few who could bring themselves to visualize great factories and bustling activity in the land of the mule and the unpainted cabin.*[103]

Nevertheless, having received funding from the Works Progress Administration in 1935 (and after navigating a quagmire of subsequent legal wrangles), the Santee-Cooper project began in the spring of 1938.

Incredibly, in barely two and a half years, upward of sixteen thousand workers moved countless millions of cubic feet of soil, forever altering the natural landscapes of six counties. Unwittingly, crews occasionally excavated—and then plowed through—areas containing prehistoric archaeological and paleontological features. As for the region's stately plantation houses, according to a 1939 survey carried out by the U.S. Department of the Interior, of the twenty-two there, only two were identified as historically significant enough to dismantle and relocate. All the rest, with their gardens, work yards and outbuildings, would be permanently submerged by the creation of the Santee-Cooper reservoirs. Besides buildings, ninety-three cemeteries, with over six thousand individual graves, had to be "resettled," although it is still unknown how many other burial sites would go undiscovered, consigning them to a watery fate.[104]

One of the over six thousand graves that had to be relocated in advance of the Santee-Cooper project's flooding. *Library of Congress.*

Meanwhile, having secured titles to 1,326 properties, at an average cost of $12.19 per acre, agents busily relocated 901 families, practically all of them poor African Americans, many still living in century-old slave cabins original to the plantation properties. As for the structures they left behind, some were saved and moved "if possible," but most were deemed unsalvageable. In those cases, property owners (not always the homes' occupants) were financially compensated.[105]

For all that was undeniably lost because of the Santee-Cooper flooding, it is still a bit reckless to condemn a development that was sorely needed for the

advancement of the state and the betterment of its citizens. When Santee-Cooper began generating electricity in February 1942, it surely ushered in "innumerable advantages" for that generation of South Carolinians. But the benefits continue. Today, the utility delivers power to nearly two million households. The man-made lakes created environments conducive to both sport fishing and waterfowl hunting. Lastly, often unnoticed, yet an extremely positive benefit was the elimination of many stagnant swamps, which, in turn, helped eradicate malaria in South Carolina by 1948.[106]

THE THOMSON AUDITORIUM
AND THE "OLD MUSEUM"

A 1974 newspaper article, in its description of the now long-gone former home of The Charleston Museum, offered what could, at best, be termed faint praise or possibly even satire: "[The] building is an architectural miracle." That miracle, it turns out was "that the building, after 75 years, is still standing.... [It] is impossible to restore, there is nothing left to restore."[107]

The article was right, but it was not the museum's fault. Decades earlier, in 1899, after benefactor John Thomson had bequeathed $30,000 to the City of Charleston, a tremendous opportunity arose. Instead of using the money to straighten King Street (Thomson's original wish), officials began planning a new building that would become, for its time, the largest auditorium in the South. After all, they thought, the local economy had been far too stagnant for far too long. The city desperately needed, as one journalist put it, "to demonstrate… the commercial enterprise of the city is not all stored away in the different cemeteries." Therefore, attracting national conventions—and providing a grand venue in which to host them—could re-elevate Charleston to its status as "Queen City of the South," a moniker it richly deserved in the decades before the Civil War. This step, it was hoped, would bring in "new men and more money."[108]

But the real concern was the impending matter of a major United Confederate Veterans reunion coming to town on May 10. Charleston would need to properly accommodate these old soldiers—and fast.

The city selected a less-than-perfect location, a decrepit park built atop a landfilled millpond, on the southwest corner of Rutledge Avenue and Calhoun Street. Utilizing only readily available materials—lumber, iron and brick—construction was completed in ninety days. Charleston was able to open the eight-hundred-seat Thomson Auditorium with two weeks to spare.[109]

From the outside, it was an impressive place. Designed in the "exposition style," meant to "dramatize architecture for the general public," the building's grand entryway boasted four towering Corinthian columns. On the inside, though, it was what one historian uncharitably termed a "maintenance white elephant" and, acoustically, offered little more than a toneless echo chamber. Nevertheless, the Confederate reunion was a rousing success, and the auditorium continued to host more conventions, meetings and conferences over the next several years, including those of the National Education Association and the League of American Municipalities. It also served as a temporary hospital while a new one was under construction between 1905 and 1906.[110]

It was not until 1907, however, that the Thomson Auditorium had its first permanent tenant, The Charleston Museum. Museum trustees had voiced increasing dissatisfaction with their current facilities, referring to the galleries at the College of Charleston as "difficult [to] access, badly lighted, over

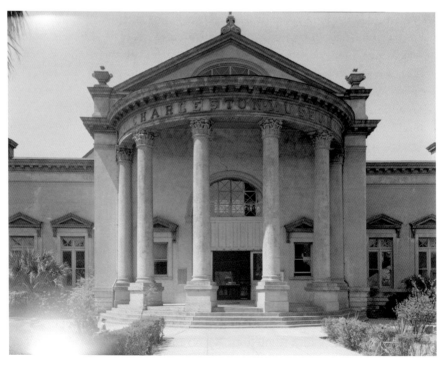

Built in less than three months, the Thomson Auditorium, near the corner of Rutledge Avenue and Calhoun Street, opened just in time for the 1899 United Confederate Veterans reunion. The Charleston Museum obtained the building in 1907. *Library of Congress.*

crowded, and entirely without workrooms and storage rooms." Their deep concerns were finally addressed on January 8, 1907, when city council gave final approval to a lease agreement on the auditorium, along with $7,500 to spend on its "remodeling and repairing." Those funds did not, unfortunately, cover the recommended "fire-proof construction," an omission that came close to costing the museum everything.[111]

Open for business at its new Rutledge Avenue location, the former Thomson Auditorium was, for a time at least, "well adapted for the use of the Museum," providing "ample accommodation for all departments." It could readily foster "a new era of development and increased service to the public." Sure enough, as time passed, The Charleston Museum, while continuing its original focus on natural history, greatly expanded its collections and broadened its interests into the rich material and cultural aspects of the surrounding area. Historic documents, silver, military paraphernalia, pottery and various textiles were accessioned. As these separate acquisitions slowly grew in scope over the decades, various departments within the museum— Archives, Anthropology, Textiles and History—blossomed.[112]

About the only thing not progressing with the rest of the museum was its building. By the 1960s, there were legitimate concerns. One benefactor remarked to Director E. Milby Burton that he was "anxious" about the possibility of the museum catching fire and losing its holdings, including *his* donated furniture. Fortunately, by the mid-1970s, Charleston City Council, museum staff and trustees agreed on the pressing need for a new building. A series of failed inspections proved that the old Thomson building was no longer a suitable home for the museum and its priceless collections. "The brick is bad, the plaster is crumbling, the wood is bad, the girders are too weak and too far apart to hold up the roof," asserted Director Don Herold. He also noted, "The roof leaks so badly we have three-foot gutters on the inside to carry the rainwater out the window....Even the site is poor. [It] is part of the filled Bennett's Mill Pond and the building, with no pilings, is literally floating on mud and sawdust."[113]

By the late 1970s, a bond issue at long last provided The Charleston Museum with a more up-to-date, architecturally sound and secure building, and museum staff began transferring materials from the old place to the new one soon after its completion. By no means a quick or easy task, all holdings save one, a large 1930s mural painted directly on an interior wall, had, by the summer of 1980, made the move safely to the museum's new location. At long last, the brand-new Charleston Museum opened in April 1981 at the corner of Meeting and John Streets, and the "new" museum still

operates there today. Sure, there has been some commentary that the current structure is not as "pretty" as the old building, but it certainly continues to show its worth, having withstood just about everything Mother Nature has thrown at it, including Hurricane Hugo in 1989.

Once it had been emptied out, there were few in disagreement that the old museum had run its course. Authorities barred its doors. Its electricity, gas and water were shut off. The mayor declared it "in a severe state of deterioration," further warning that, since "there was never any fire protection for the building…its location next to a home for the elderly makes threat of a possible fire very alarming." With that, officials began debating how and when to demolish the building and, in the meantime, rezoned the lot back to a public park. On the night of Sunday, October 18, however, their work was done for them.[114]

The fire that "swept through the old Charleston Museum building… throwing flames scores of feet into the air and collapsing the roof" caused a neighborhood evacuation, injured eleven firefighters and destroyed one fire truck when a wall collapsed on it. The next day, investigators determined the blaze to be "a suspicious one." Its cause remains a mystery.[115]

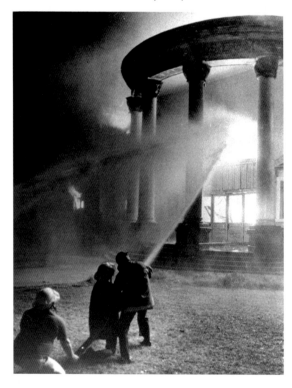

Firefighters near the front entrance of the former Charleston Museum building on Rutledge Avenue, 1981. *Courtesy of The Charleston Museum, Charleston, South Carolina.*

The former Charleston Museum front steps and Corinthian columns still stand at present-day Cannon Park, preserved after a fire in 1981. *Photo by Kim Graham.*

If nothing else, the fire that burned down the old Charleston Museum helped revert the property back to its original use as a public space, today's Cannon Park. Unlike its 1890s weed-wild predecessor, the current park encompasses almost three acres and offers a lush lawn, vibrant plant life, a playground and a perimeter walkway. In addition, one might also spot on its eastern border four ghostly Corinthian columns projecting into the air from a fragmented foundation, the only surviving elements of the otherwise lost Thomson Auditorium.

St. Matthew's Lutheran Church Steeple

When work was completed on St. Matthew's Lutheran Church in 1872, its towering 257-foot steeple made the King Street building the tallest in South Carolina. The church's primarily German congregation had grown steadily by the turn of the twentieth century and, as a testament to its success, purchased a set of ten bells in 1909, renovated parts of the sanctuary in 1925 and, amid the Great Depression, even constructed an $81,000 Sunday school building. Through it all, the church's lofty steeple continued to be among the congregation's most regal (and certainly visible) accomplishments. Despite its height, it had withstood its share of local disasters, including the earthquake in 1886 and a series of major hurricanes from the 1890s onward. When it caught fire in 1965, lamentably, all the congregants could do was stand and watch and pray.[116]

Fires—accidental or not—appear to be the single greatest cause of property loss around Charleston, and for whatever reason, houses of worship seem particularly vulnerable. In the aftermath of the February 1835 fire, which claimed more than sixty buildings, one newspaper reported a specific note of regret: "The most melancholy feature in the catastrophe is the destruction of St. Philip's Church, the oldest public edifice in this city, having been built in 1723, and embellished throughout its interior in a style of Architecture which vividly associated us with the past and imposed on the mind impressions of solemn grandeur and religious awe."[117]

Besides St. Philip's (the present structure having been rebuilt by 1838) and the aforementioned Circular Congregational Church, over the centuries, plenty of other venerable places of worship have had to deal with fire's devastation. On Hasell Street, both St. Mary's Roman Catholic Church and its across-the-street neighbor, Kahal Kadosh Beth Elohim, founded in 1749 and one of the earliest Jewish congregations in colonial America, burned down in the Great Fire of 1838. The massive conflagration "made desolate" over one quarter of the entire city. Despite the devastation, both were reconstructed by 1840. Southward on Meeting Street, First (Scots) Presbyterian Church partially burned in 1945, when flames spread from an adjoining building and destroyed the original 1814 wall behind the pulpit.[118]

In the early evening of January 13, 1965, according to records at St. Matthew's Lutheran, "an incandescent light ignited some painting materials in the church" and quickly spread to the roof. Firefighters, starting at about 7:00 p.m., worked furiously to control the blaze and, by all accounts,

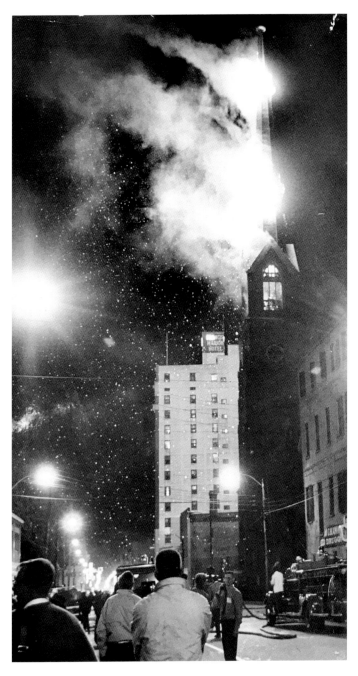

St. Matthew's Lutheran Church steeple, the tallest in the city, engulfed by flames and moments before its collapse, 1965. *Courtesy of St. Matthew's Lutheran Church Archives.*

appeared to have been successful by about 8:45 p.m. Indeed, the assembled crowd thought the steeple would again prevail.[119]

After about an hour, the crisis, according to one reporter, appeared to have subsided. The huge crowd of onlookers had thinned a bit. Even the pastor and members of the church council, who had rushed to the scene earlier, had by now retired to the nearby police station to discuss rebuilding plans. Then the wind picked up.

At about 10:00 p.m., a small flicker of flame "about 75 feet from the top" of the steeple spread swiftly upward. Though firefighters from all thirteen city stations were on hand, drenching the smoldering edifice from dozens of angles, none of their equipment could reach that high. Unable to prevent the inevitable, fire and police personnel began a mad scramble up and down King Street, clearing equipment and moving spectators back a full block. Then, after about fifteen minutes, "a horrible gasp" arose from the crowd, and the state's tallest steeple became the world's largest dart. "Two huge fireballs exploded from the broader portion of the steeple near the pinnacle," wrote one eyewitness. Another described how its "gilded weather vane continued

Surrounded by scaffolding and fire damage, undeterred members of the St. Matthew's Lutheran congregation resumed Sunday services in their sanctuary. *Courtesy of St. Matthew's Lutheran Church Archives.*

to point correctly to the southwest until the end," as it lurched, upended and crashed down. Its tip, like a massive needle, penetrated eighteen feet deep into the earth as "millions of sparks saturated the sky." [120]

Amazingly, and certainly despite the hellish ordeal, significant portions of the sanctuary interior survived the flames. "Walls," the pastor noted, "showed little evidence of scorching….Pews were unblistered," and all the windows but one remained "untouched," including a trio of spectacular stained-glass masterpieces positioned behind the west-end altar. Repairs to St. Matthew's began almost immediately. By October, crews had poured new concrete flooring, steel roof beams were in transit and each of the original ten bells was undergoing reconditioning. Naturally, particular attention was paid to the design of the new steeple. On March 29, 1966, its three sections, reconfigured with copper sheathing and topped with a gold-leafed weather vane, were hoisted into place by crane operators. [121]

Interestingly, not all of St. Matthew's original steeple is lost. Left in place as a not-so-subtle reminder of that dreadful event, the sheered, eighteen-foot top is still where it fell, deeply embedded in the ground, with only a few feet protruding upward.

THE GUARDHOUSE

The possibility of earthquakes in Charleston should not have come as a complete surprise, with several reported in colonial times. One powerful enough to be felt throughout the peninsula, yet "did no damage," occurred on May 19, 1754, and another, recorded fifty-five years later, was harmless— at least according to contemporary accounts. Local newspapers, perhaps attempting to keep everyone's guard up, reported at length about seismic events elsewhere: Calabria (Naples, in 1783), Boston (1791), Baltimore (1810) and Antigua (1843). But the attitude of most Charlestonians was "out of sight, out of mind." [122]

All that changed in the summer of 1886. After dark on August 31, a series of "five successive shocks" tore through the Charleston peninsula. As one historian wrote:

> *Chickens screamed, cows lowed, cats cried, dogs howled. Church bells and doorbells clanged. Granite covers flew from well shafts, propelled by geysers of water and mud….Yards and streets flooded with bubbling water.…On*

lower King Street a waterspout dumped six inches of sand across a patch as big as a baseball diamond. Heavy marble funeral urns vaulted from their pedestals and rammed into the ground. In the cemetery at Circular Congregational Church, a stream of water and sand vomited from a grave.[123]

The cataclysm created near-complete confusion and disorder. Citizens took to the streets to avoid collapsing roofs, walls and chimneys. Many "prayed and laughed in their frenzy of despair in turns." Along Meeting Street, "the city is wrecked," observed an anonymous journalist. Hardly any of the larger structures about town were unscathed. Besides severe structural damages, "quite a number of cellars in all parts of the city were unaccountably filled with water where there had never been any water before." So destabilized was First (Scots) Presbyterian Church that city inspectors judged the entire sanctuary a danger, condemned it and began planning its demolition. Thankfully, a lone Boston-based architect, Thomas Silloway, successfully argued that the building could be rehabilitated. Some impressive alterations were needed to repair the place, including reinforcing the roof, bell towers and walls. Workers also reincorporated the old box-pew doors as wainscoting on the interior side walls, where they can still be seen today.[124]

Down the block on Broad Street, there was a less happy ending. On the southwest corner of today's famed Four Corners of Law, stood, albeit barely, Charleston's Guardhouse. It was the third in a succession of such buildings, which, since the 1760s, had served as headquarters for Charleston's various policing organizations.

As the city had grown steadily in the 1830s, both in size and population, officials naturally sought to increase the visibility of the civic guards (a quasi-military unit that by mid-century was a more formal, uniformed police force) and make a blunt statement about their societal role. To achieve this goal, simply renovating the old 1769 frame building would not do. A new structure, one that would "make a forceful architectural statement, asserting the power and authority of the guard on all fronts," was wholly necessary. In addition to its commanding presence, the new Guardhouse would fit nicely into a larger antebellum plan to revamp Meeting Street into a glorious metropolitan landscape.[125]

Hiring Prussian-born architect Charles Reichardt, who had just finished up his work on the Charleston Hotel a few blocks away on Meeting Street, city council approved $23,000 for what was described as "a two story

building on a foundation a little raised…with an imposing pediment." This description was quite an understatement. By the time it was finished, the new Guardhouse was a considerable architectural achievement, stretching 56 feet along Broad Street and a whopping 132 feet down Meeting Street; 30-foot-high perpendicular Doric colonnades, which mimicked those of ancient Rome, adorned each street front and extended over the adjacent sidewalks.[126]

Charleston's new Guardhouse was a handsome, almost imperial-looking building, certainly befitting its purpose, and described by Mayor Henry L. Pinckney as "not only one of the largest, but one of the most beautiful edifices in the City, as highly ornamental in its appearance, as it will be useful and efficient, for all the Objects for which it was designed." Even after 1856, when its longer eastern-facing colonnade was dismantled to accommodate the widening of Meeting Street, the Guardhouse remained an imposing landmark and survived both the Great Fire of 1861 and the lengthy Union bombardment over the latter half of the Civil War.[127]

Woefully, for all its splendor before the earthquake, it was a mess afterward. With a partially collapsed roof and its Broad Street façade and portico now mostly in pieces scattered about the sidewalk, the Guardhouse's damages proved too extensive for repair. The once outstanding public building, with

The Guardhouse at Meeting and Broad Streets after the earthquake of 1886. *Courtesy of The Charleston Museum, Charleston, South Carolina.*

its dominating Doric columns that had, for decades, "symbolically evoked resolute power," was unceremoniously razed, with the property sold, by recommendation of the Commissioners of Police, to "purchase…a lot in the central portion of the city" for "a new police station and new fire engine houses, built in modern style and adapted to the wants and requirements of a growing city."[128]

5

THE COMMON DEFENSE

Seeming to defame the once formidable 1861 Charleston harbor defenses, an anonymous correspondent writing to a local newspaper opined, "Fort Moultrie…looks quite lonely and forsaken. Fort Sumter, only a short distance from Moultrie…is fast becoming useless for the purposes of a fort. Castle Pinckney has been turned over to the lighthouse department and is used as a storehouse for supplies. Thus, have the mighty Fallen!"[129]

Fortunately, for the sake of interpreting Charleston's wartime history, all three of these fortifications are still standing—two of them, Moultrie and Sumter, open to the public. It is vital to remember, however, that they are a mere three of the hundreds of military installations that once dominated the regional landscape. Charleston's military history—both victories and defeats—is voluminous, extending back to the 1690s and encompassing major and minor conflicts through the end of the Civil War. Early on, especially, thick walls, armed batteries and high bastions were the order of the day. Permanent defenses were essential to a colonial city like Charleston with historically less-than-peaceful neighbors. Royal Governor William Henry Lyttelton drove this point home in 1757, practically demanding that the Commons House of Assembly construct strong defenses "without delay…to prevent this place from falling an easy Prey to the Enemy in case of Attack."[130]

Yet attacked the city was—and repeatedly so. Today it is still difficult to quantify how drastically wartime activity altered and scarred the Lowcountry.

In some cases, entire buildings were lost. For instance, in July 1863, stationed on Morris Island, an officer of the Third Rhode Island Heavy Artillery Regiment wrote: "How many soldiers will recall the old Beacon House, from which we quietly detailed the floor-boards and sheathing 'til only the frame and roof were left?" As he described, this once magnificent mansion, constructed near the island's center, was picked apart, bit by bit, by both Confederate and Union troops for use in their siege lines and batteries. Still standing but a mere "skeleton" of its former appearance, the Beacon House eventually "succumbed to a southern gale."[131]

It really should not be at all surprising that most of Charleston's military defenses are gone. With the arrival of peace in 1783 at the end of the American Revolution and in 1865, at the end of the Civil War, there was not much enthusiasm for preserving ruined reminders of an insecure, violent and, above all, deadly past. Typically built in haste with only function in mind, many of these defensive fortifications were temporary to begin with; later ones were made up of little more than dug-up, hard-packed earth and laid out in response to the ebb and flow of battle. Nature, too, was bound to take its toll.

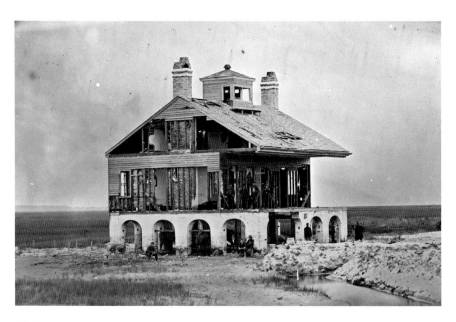

The Beacon House on Morris Island, circa 1864, having been stripped of its building materials by both Union and Confederate troops. *Library of Congress.*

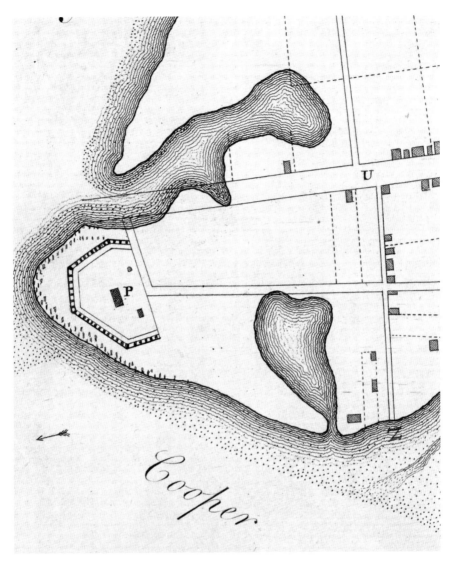

Detail of "The Ichnography of Charles-Towne, at High Water," showing the 1739 layout of Broughton's Battery (marked "P"), at the southern tip of the Charleston peninsula. *Map reproduction courtesy of the Norman B. Leventhal Map Center at the Boston Public Library, public domain.*

As for the sturdier, more conventional forts and batteries that guarded the city for generations, theirs was a far more common fate. Broughton's Battery, for instance, a daunting forty-gun, brickwork bastion, constructed in 1736, guarded the city's southern point, near Church Street. Doubtless

a rather intimidating sight for any would-be French or Spanish invader, it stood steadfastly for nearly half a century, until the end of the Revolutionary War, when the city ordered its demolition.

SIEGE TRENCHES AND THE "HORNWORK"

Standing beside the Second Presbyterian Church and taking a quick glance eastward down Charlotte Street reveals something a little unfamiliar to most locals: hills. Nothing too conspicuous, surely, but certainly unique when compared to the remarkably flat landscape of Charleston's barely above sea-level peninsula. Given their location and pattern, and when put in context with several period maps, it has long been rumored that these subtle, rolling humps were leftover scars from a now-backfilled and built-over network of sprawling siege lines dug by British troops in advance of their victorious 1780 Charleston campaign. But, alas, this is not the case. Archaeological studies have shown no hints of disturbed earth within this corridor, and geological reports agree that the terrain, while unusual, is naturally high ground.[132]

Amazingly, it was not until June 2017 that archaeologists uncovered what is likely the first actual section of those redcoat reticulations. Having dug a series of neck-deep pits around the rear work yard of the Aiken-Rhett House, participants in The Charleston Museum's summer archaeology field school reached a 1780s-period soil layer displaying evidence "consistent with a filled ditch."[133]

Marching across Simmons (Seabrook), Johns and James Islands, crossing the Ashley River to the mainland above Charleston and then descending on it from the north, Sir Henry Clinton and upward of eight thousand well-disciplined British troops were, by the spring of 1780, decently positioned to capture the city and, they hoped, regain the Crown's military initiative. Not underestimating his Patriot foes, however, Clinton was not about to act foolishly. Most certainly, patience and strategy would have to be expertly employed, since Charleston was by no means defenseless.

For the Brits, the single greatest obstacle to defeating and occupying Charleston was overcoming the city's north-facing defenses, near the center of which was an intimidating "hornwork" along the present-day border of Marion Square. Made up of an economical recipe of oyster shells, lime and sand—a mixture better known as "tabby"—the hornwork was named,

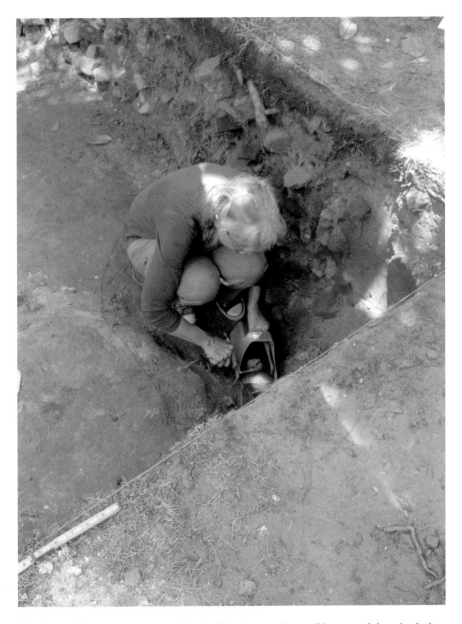

Charleston Museum archaeologist Martha Zierden examines soil layers and deposits during a 2017 excavation at the Aiken-Rhett House. The dig exposed what was likely one of the 1780 British siege trenches. *Author's photo.*

Detail of "Plan de la ville de Charlestown," showing the layout of the defensive hornwork, 1780. *Library of Congress, Geography and Map Division.*

perhaps aptly, for its protruding pair of half-bastions that, if viewed from the air, resembled a set of horns "atop the head of beast."[134]

The hornwork was a gargantuan edifice, encompassing some five full acres and well-armed with eighteen cannons overlooking a wide moat. Attacking it headlong from the front would have been suicidal, and Clinton knew it.[135]

Encamped within two miles of the hornwork, enemy troops, on April 1, 1780, began not marching toward town but rather digging their way to it. "We observed that they had broken ground in several places about 1100 yards in our front," wrote Major General Benjamin Lincoln, commander of the Charleston garrison. "Their next work appeared, the morning following on our left about nine hundred yards distance, on the night after they opened a third work, about six hundred yards from our right."[136]

By early May, all that Patriot defenders could do was watch from within their now-doomed hornwork. British grenadiers, light troops and infantry had shoveled tens of thousands of pounds of earth to create an almost two-mile-long, three-to-four-foot-deep latticework of trenches from which they could protectively maneuver, mount, aim and fire their large siege guns. On May 11, Lincoln, writing to his adversary Clinton, admitted that he was out of options:

> *The citizens in general* [are] *discontented, the Enemy being within twenty yards of our Lines and preparing to make a general assault....Many of our cannon* [are] *dismounted and others silenced by want of shot, a retreat being judged impracticable and every hope of timely succor cut off, we are induced to offer & excede* [sic] *to the terms* [of surrender].

Charleston capitulated the next day and was thereafter occupied until December 1782.[137]

The war was far from finished, but both the city's defensive hornwork and the enemy's well-dug siege lines *were*. As standard procedure, British officers moved quickly to marshal work gangs to backfill their own siege lines, lest the Patriots utilize them in some future attack. With that, practically all evidence of the trench lines was lost within weeks of their completion. At war's end, any other physical reminders of this strategic site rapidly vanished, as the area was transformed by development.[138]

Thankfully, archaeologists changed all that in the summer of 2017. By exposing what was likely a redcoat approach trench, researchers can now use the site as a precise point of reference against several period maps and, with a little luck, positively ascertain where the rest of the lines were.[139]

Certainly larger and better built, the hornwork fared little better than the siege lines. The emergence of peace in Charleston and the rest of independent America brought about some serious changes in landscaping and property development. The city incorporated in 1783, and a year later, the state legislature approved the demolition of all wartime fortifications on public lands. By year's end, most were gone.

Today, the acreage north of Calhoun Street between Meeting and King Streets, the same site where a large, strong and undoubtedly frightening military installation once ferociously guarded Charleston's northern front, comprises Marion Square. This beautiful, grass-covered park offers only a pair of often-overlooked hints that anything even remotely hostile ever occurred there. The first, a historical marker, gives passersby a brief narrative of the 1780 siege. However, without the outstanding efforts of a former National Park Service intern in 2010, it is highly doubtful whether this plaque would ever have been erected. Marion Square's second telltale sign of the Revolutionary War, while at least an original artifact, is inadequately interpreted. Near the west side, an iron fence encloses a weathered and worn chunk of tabby, the sole remaining piece of Charleston's once-great hornwork. Alas, despite its significance to the Patriot cause, an inscription of only nine words is mounted upon it. Aside from these two sources, no other signage can be found anywhere in the park to alert visitors that they are strolling "through the site of the American headquarters of one of the most important battles of the American Revolution."[140]

Only this small remnant of the once massive hornwork that guarded Charleston remains near the west side of Marion Square. *Author's photo.*

THE "NEW LINES"

Morris Island, an otherwise lonely, mosquito-ridden stretch of marshy terrain about four miles south of town, near the mouth of Charleston Harbor, fell into Union hands in September 1863. Though it is one of the more overlooked events of the Confederacy's most dismal summer, it was no less a massive loss for Charleston, the fallout of which would continue unabated straight through to war's end. For the previous two months, even in the face of remarkable rebel resistance at Battery Wagner, Federal forces had established positions on the island. Controlling most of Morris by the end of July, the Union's heavy guns soon commanded much of the harbor and, together with the U.S. Navy blockade, effectively sealed off Charleston from the sea. Worse still, the Union's inland-facing batteries, each bristling with rifled artillery and led by trigger-happy General Quincy Adams Gilmore, began firing explosive and incendiary rounds at strictly civilian targets. "The shells," wrote Emma Holmes in her diary, "will burst in the lower part of town, but the fragments fly over a mile up town.…Last night one of them set a house on fire and as soon as our demon foes saw the blaze and knew our firemen were at work, the shells were fired thick and fast."[141]

As the enemy's indiscriminate shelling continued into autumn, Mayor Charles MacBeth began doggedly urging noncombatants to get out of town or, barring that, at least out of range. The newspapers were not calming too many nerves either, with one reporter writing, "[L]et us resolve on a Saragossa [Actually, Zaragoza, a besieged Spanish city the French failed to take in 1808] defense…manning and defending every wharf—fighting from street to street and house to house—and, if failing to achieve success, yielding nothing but smoking ruins and mangled bodies." Concern had also reached Governor Milledge Bonham in Columbia, who sent word to Confederate general Pierre G.T. Beauregard in Charleston (as if he needed to be told) to begin "as immediately as possible…to work on additional fortifications for the defense of the city," including adjacent James Island.[142]

Ever since the war began more than two years earlier, most tactically minded men familiar with the area—like Beauregard—knew that James Island was, after Morris, the ripest for attack. Yankees, needing to sidestep Forts Sumter and Moultrie and publicly admitting "that James Island was the direct and substantially the only path to Charleston," had already landed troops there once before in 1862. They attacked at Secessionville on June 15 but, despite their tremendous numerical advantage, suffered heavy casualties and were forced off the island. That was ancient history as far as Beauregard

was concerned. Surely, his enemies would be back, next time by both land and sea and, more importantly, having learned from their earlier mistakes.[143]

As the Union army gained complete control of Morris Island, its dangerous proximity to James Island forced Confederate engineers to act fast. Beauregard, after inspecting the 1861–62 earthwork defenses, which snaked rather haphazardly across the island, knew they would not do, especially since they did not cover much of its western side, leaving the Stono River wide open to enemy gunboats. Because the Union's new-fangled rifled artillery, developed in the 1850s, was now making mincemeat of tough brickwork forts like Sumter in Charleston and Pulaski in Savannah, Beauregard, like the British before him, was going to have to start digging.

Calling on his most trusted engineer, Lieutenant Colonel David B. Harris, Beauregard gave instructions "to lay out and construct a shorter more easily defensible line of earthworks on James Island from Dill's Plantation on the Stono River eastward to the older Secessionville Fortifications near Fort Lamar." Corresponding with Governor Bonham, Beauregard asked for an immediate "requisition of three thousand negroes" to supply the necessary labor to make James Island's "New Lines."[144]

The slave labor force would increase by a thousand before the work was finally complete. Breaking ground on August 9, 1863, the workers' efficiency was nothing short of astounding. In just twenty-days, upward of four thousand slaves had exerted themselves mightily to build a continuous defensive line over two and a half miles long, which included five earthwork batteries, all interconnected by an "indented line of infantry trenches" (referred to as "cremailliere"). Among the batteries on the western banks of the Stono was Battery Pringle (named for Captain Robert Pringle, who had died defending Battery Wagner several weeks earlier). It was a menacing eight-gun emplacement, complete with full traverses, powder magazines and a bombproof (enclosed shelter).[145]

By late winter, smaller groups of commandeered slaves were "pushed forward night and day" to add six more batteries to the lines, which Confederate ordnance officers immediately equipped with all manner of artillery, some transferred from other positions around the Lowcountry, a few others from Savannah and Richmond. By early April 1864, Beauregard appeared satisfied with James Island's defenses and answered an order to service in Virginia.[146]

Upon completion, the New Lines were indeed an impressive site—from the outside. Inside, it was a quite a different story. By 1864, there were but a few soldiers available to fill the batteries, most others having been transferred

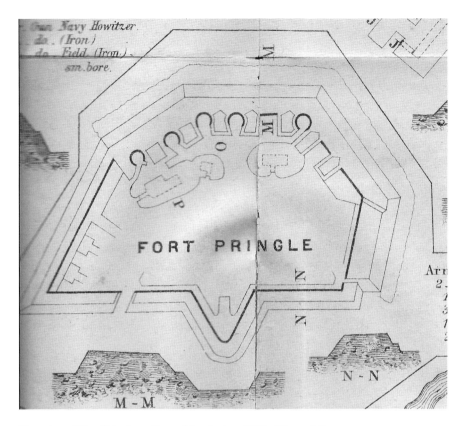

Plan view of Fort Pringle on James Island, circa 1865. *Library of Congress.*

to more urgent fronts in Virginia. For the ones who remained, they would be undermanned and under stress. At Battery Pringle, though built to house several hundred soldiers, a rather woeful inspector general's report stated that, despite being properly fitted with appropriate artillery, only a skeleton crew of four officers and seventy-eight enlisted men—thirty-two of them shoeless—occupied the place. In addition, the bombproof was "not covered with sufficient earth," and the two magazines each had "wet interiors," clearly an unfit environment for black powder storage.[147]

Obviously, the poor conditions at Pringle (and plenty of other spots along the New Lines) were of no concern to the Union forces, who, just as Beauregard had predicted, went back on the offensive in July 1864. Nevertheless, from the second through the eleventh, the New Lines held, successfully defending James Island and, by default, Charleston. Scores of Union infantry landing on the southwestern side were blasted from their

Light detection and ranging (LiDAR) image, circa 2009, showing intact remnants of James Island's Battery Pringle on the Stono River and portions of General Beauregard's 1863 New Lines extending westward. *Courtesy of the South Carolina Battleground Preservation Trust.*

positions before the week was out. Offshore, Admiral John A. Dahlgren, commander of the South Atlantic blockading squadron, recorded that the accuracy of fire from his gunboats on the Stono "was considerable" and that each shot produced "a cloud of earth thrown from the work[s]." In the face of it all, however, the New Lines continued to hold fast. The Union infantry—or what was left of it—limped back to Morris Island, while Dahlgren withdrew his warships.[148]

Today, most of General Beauregard's New Lines are predictably gone, if not plowed over and farmed in the late nineteenth century, paved over or built upon in the twentieth. Luckily, a few sections remain. Battery Pringle and its neighboring batteries, to the north and east, are still very much intact, preserved and protected by The Charleston Museum. Other places, particularly near the junction of today's Riverland Drive and Grimball Road, retain a few perceptible (and now quite fragile) ground undulations, all characteristic leftovers of the rifle pits and trenches that ran between the scattered batteries. In addition to The Charleston Museum, further efforts by the South Carolina Battleground Preservation Trust, established in 1991, are ensuring that whatever remains of Beauregard's New Lines will not be lost. Utilizing technology, such geographic information system (GIS) mapping and light detection and ranging (LiDAR) imagery, the trust, having already saved over two dozen important military sites throughout the state, continues to gather essential data to help better understand and interpret each of them.[149]

WEST ASHLEY'S POWS

A fact largely forgotten amid the multifaceted history of the Second World War is the U.S. Army's operation of over five hundred prisoner-of-war camps within *this* country's borders. These domestic internment sites

detained almost 400,000 German prisoners between 1942 and 1945, with several hundred held in Charleston. Sparsely populated at first, by May 1943, the South Carolina camps experienced a large influx of German prisoners, following Allied victories in North Africa. Since the 1929 Geneva Conventions mandated "adequate food, shelter and health care," local authorities took the necessary steps to ensure that every rule was followed. [150]

Charleston's five German POW camps were nowhere near what one might consider large or even recognizable as prisons. Each was established as a rural "sub camp," housing small numbers of prisoners who could provide additional labor "to assist in fall harvests" (since most local farmworkers had either enlisted—or been drafted—into military service). The largest one was located just west of the Ashley River (an area unsurprisingly called "West Ashley"), near present-day Colony Drive, less than two miles from the historic district. The compound enclosed eighteen acres within an imposing barbed-wire fence, holding about five hundred POWs at its peak. It was nothing fancy, described as a small "tent compound…with wooden floors and sides" and one or two "rustic buildings." [151]

At war's end, the army systematically repatriated the German POWs and soon closed and razed the smaller South Carolina camps. Interestingly, the West Ashley camp's central "community building" survived and continued—for at least a little while—to serve the neighborhood as a "multipurpose clubhouse…used for local supper clubs and Boy Scout meetings." Yet while the building predictably deteriorated over the ensuing years, its sturdy brick fireplace and attached chimney still stood as late as 2015. Each of these features was a rather noticeable—dare one say, elegant—reminder of the old POW camp, appearing "like the neglected remnant of a fashionable outdoor living space." Adorning either side of the nearly twenty-five-foot-high chimney were two skillfully engraved concrete plaques, both marked "German Prisoners of War." [152]

Now, for a city as preservation-conscious as Charleston, one might reasonably assume that protecting such a vestige of war would be a worthy mission, without question. Not so, in this case. For starters, the structure's location—smack-dab in the middle of a privately owned lot—severely obfuscated any possibility of initiating improvements. Far worse was the fact that the Germans had built the fireplace and chimney themselves, creating a completely understandable quandary for the Jewish property owners. One family member stated quite clearly, "Every time I see the structure, it makes me think about the ovens." [153]

Still, the family's feelings and property rights notwithstanding, a decent number of individual preservationists about town made their voices heard and, and by the summer of 2014, had persuaded Charleston City Council to propose a "landmark overlay zone" to protect the structures. "In other words," one reporter wrote, "Jews would be required to keep a Nazi-built relic on their property" should the city pass such a motion. The family, meanwhile, despite having a literal brick-and-mortar reminder of Nazism overlooking its property, still worked to accommodate several proposals to remove the fireplace and chimney and preserve them elsewhere, even offering to financially assist the process. There were absolutely no takers.[154]

Humanely, Charleston's Planning Commission wasted little time denying "protected historic status" to the POW camp's surviving brickwork. City council soon agreed and, on July 14, 2014, granted the family permission to get rid of it once and for all. Even after the vote, a family spokesman reiterated that the offer still stood and "if somebody would like to come and take it away, we're fine with that." Still, there were no responders, and thus the last pieces of Charleston's German POW history were torn down on November 19, 2015.[155]

6

"WELCOME AND GENEROUS
ENTERTAINMENT"

On January 31, 1736, the newspaper announced: "On Thursday, the 12th of February will be open'd the New Theatre in Dock Street in which will be perform'd The Comedy call'd 'The Recruiting Officer.'" Later to be known more popularly as the Dock Street Theatre, it was the first building constructed in British North America specifically for hosting theatrical performances. With Charleston being the first city in colonial America to build a playhouse for its citizenry, it is undeniable that entertainment was, for better or worse, serious business.

Besides the theater, locals and visitors alike enjoyed all manner of amusements. Grand balls hosted by the St. Cecilia, St. Andrew's and the South Carolina Societies attracted huge crowds that included many, if not all, of the elite planter class, a group that eighteenth-century naturalist Dr. Alexander Garden censured "absolutely above every occupation but eating, drinking, lolling, smoking, and sleeping."[156]

For others, there were assorted sports and pastimes, including "bear-baiting," "bull-baiting" and "foot ball playing." Gambling appears ubiquitously within Charleston's social records, its prevalence described by one local cleric as a permeating "vice corrupting of youth and debasing to manhood." In that same vein, horse racing was a particularly popular spectator—as well as betting—sport, even though the local newspaper assured the public that "the gentlemen of the turf, like the ancient nobles…never ran their horses for the pecuniary value of the prize to be won."[157]

With so much to see and do in the cosmopolitan city that Charleston had become, "intense social activity" dominated the more temperate months. Once autumn harvest had been completed, wealthy planters migrated into the city to commingle with their upper-crust brethren. This social season, or what many in the eighteenth and early nineteenth centuries simply dubbed "The Season," typically encompassed late autumn, winter and early spring. Perhaps Alice Izard said it best in a letter to her mother, fearing—or feigning to do so—that visitors unfamiliar to Charleston during this time "would think it the most dissipated place in the World. My head is almost giddy with hearing of the multiplicity of Festivities."[158]

The Dock Street Theatre enjoyed only a few years of hosting operas, plays and concerts. The Great Fire of 1740 destroyed the place and hundreds of other properties. Its loss, however, should not suggest, in any way, that live performances ceased.

To be sure, plenty of other venues for entertainment have come and gone over the course of Charleston's rich history. Esteemed Irish-born architect James Hoban, designer of "the president's mansion" in Washington, D.C., (now called the White House) put forth his design for a new "Charleston Theatre," facing Broad Street at New Street. By all accounts, it does not appear that Hoban skimped on the scope or details. Announcing in the newspaper on August 14, 1792, that workers were preparing to lay "the Corner stone of the foundation" within the week, he further described his theater's grand proportions: 1,200 seats facing a 56-foot-wide stage, all within a structure "125 feet length, the width of 96 feet, the height 37 feet, with a handsome pediment, stone ornaments, a large flight of stone steps, and court yard pallisaded."[159]

Though closed for a spell in the late 1790s—thanks, in part, to stiff competition from a nearby French-language theater on Church Street—it reopened in 1800 and, despite a couple of business interruptions, operated more or less successfully throughout the first quarter of the nineteenth century. By the 1830s, however, the Charleston Theatre had lost much of its popularity amid a depressed economy. Closed and shuttered, it was ultimately sold to "the faculty of the Medical College of the State of South Carolina for the sum of $12,000." Alas, the college outgrew its need for Hoban's once grand theater. It was again sold off in 1848 and demolished.[160]

Obviously, many—but surely not all—of Charleston's entertainment venues, such as taverns, long rooms and concert halls could be as glamorous as Hoban's playhouse. Such buildings of past centuries, moreover, were viewed as disposable commodities, all available for the right price, with no thought of preservation. Theaters were and still are highly desirable buildings long after

their last curtain calls, as their vast interiors can be reworked into smaller offices or shops and subsequently rented. King Street's Riviera Theatre, for example, shut down in 1977 and was nearly demolished in the mid-1980s, but it is now a privately owned conference center and ballroom.[161]

HARMONY HALL

On August 5, 1786, the *New York Independent Journal* innocuously announced: "We hear from Charleston, S.C…a Mr. Godwin, comedian, has leased a lot of land for five years and erected a building called Harmony Hall, for the purpose of music meetings, dancing and theatrical amusements." Having opened a few weeks earlier, it was the peninsula's first post–Revolutionary War theater and a welcome social outlet for those Charlestonians looking to embrace their hard-won independence. Situated "in a spacious garden," near the corner of present-day Calhoun and King Streets, Godwin, in his first few months of operation, at least, was careful to maintain discretion, oftentimes rewording advertisements for his theatrical performances and calling them "concerts" so as not to awaken "prejudice of most respectable citizens against plays and actors."[162]

Why such a fuss? In Charleston, some policies initiated by the 1774 Continental Association (a set of fourteen articles that pledged American unity against British oppressions) were, as far as local officials were concerned, still quite valid—especially its provision to "discourage every species of extravagance and dissipation, especially…all kinds of gaming...exhibitions of shews [*sic*], plays, and other expensive diversions and entertainments."[163]

Taking matters a step further after the war, in September 1783, Charleston City Council established its own ordinance "to restrain the exhibition of Theatrical Entertainments within the City of Charleston." It continued in no uncertain terms:

> *Forasmuch as the exhibition of theatrical entertainment within this city… may prove of injurious consequences, by corrupting the morals of youth, apprentices and servants, and encouraging idleness, riot and disorder.… All and every person or persons who shall act or perform, or be aiding or assisting in the acting, performing, or exhibiting of any tragedy, comedy, farce, interlude, or other theatrical entertainment…shall forfeit and pay a fine of ten pounds sterling for every such offence* [sic].[164]

Fortunately for Godwin, this new law affected only properties and people within city limits, which Harmony Hall was not—just barely. With an address no more than ninety feet away, on the north side of what was then Boundary Street (appropriately named, as it marked the city's northern border), the building was immune to city council restrictions. Thus, Godwin was free to capitalize on Charleston's lust for culture, all the while thumbing his proverbial nose at what he doubtlessly considered draconian decency laws. He operated without limitation, hosting all sorts of visual and performing arts, even establishing a small school that offered music, acting, dancing and special classes for "swordsmanship."[165]

For a while, Harmony Hall was a local delight. Sure, it riled city council, and reports of its raucousness eventually made their way to state legislators, but even these men were powerless against it—until November 1786, when things went terrifically awry:

> *A riot took place in the theatre on Wednesday last* [November 8], *owing to a disappointment which the audience received in their expectations that Mr. Godwin would dance. As the dance had been advertised for some time, and no apology being made for it's* [sic] *omission, a great part of the audience grew outrageous, & threw several bottles upon the stage, one of which was returned by Mr. Godwin, who also came forwards and flourished his sword; a number of gentlemen jumped upon the stage, but happily several of them being cool and dispassionate, the tumult ended without any dangerous consequences.*[166]

The disturbance, unsurprisingly, did not sit well with the authorities or some high-minded individuals about town. Letters flooded local newspaper offices, one of them from an eyewitness, who wrote, "I was last evening at Harmony Hall, and such infamous low behaviour I do not remember ever to have seen before." Accusatory rumors that Godwin had purposely hoodwinked his patrons did not help matters, but as his wife was quick to point out to reporters, these were entirely unfounded, since she herself had announced a week earlier, "On account of a hurt Mr. Godwin received on his foot, the play is deferred."[167]

Desperate to make things right and save their livelihoods, the Godwins hastily converted the main assembly room into an open venue for (hopefully more peaceful) "Lectures, Poems, Odes, and Orations on Various subjects." Mrs. Godwin furthermore sent word to the public that, to avoid future calamities, "[t]he house will be better lighted towards the front" and "proper care taken to prevent confusion or disputes."[168]

Despite these promised corrective measures, the damage had already been done. Spurred on by clergymen, civic groups and the like, the state in 1787 passed a law expanding Charleston's theatrical prohibitions, effectively dooming whatever future Harmony Hall might have had. On August 15, 1788, the Godwins placed their final ad in the *City Gazette and Daily Advertiser*: "The subscriber…will sell the house and lot where he now lives…including the place called Harmony Hall…sufficiently spacious to contain on one floor one-hundred artizans [*sic*]." After some years, the once grand structure fell into disrepair and was eventually torn down, near the turn of the nineteenth century.[169]

Today, no building stands at Harmony Hall's former location. Its former property, along with nearly seven acres to the north and east of it, is today known as Marion Square, a former military parade ground for the Fourth (or Charleston) Brigade of South Carolina and later The Citadel. In 1882, it became a public park.

Shepheard's Tavern and "The Corner"

The bank at 48 Broad Street towers above the northeast corner of Church and Broad Streets. Despite its handsome appearance, many Charleston residents are quick to remind tourists that "it's new." Now, it is important to note that the word *new* is quite a subjective term when it comes to Charlestonians and their historic district, especially in a city founded in the late seventeenth century. Still, this particular edifice, built in the late 1920s, no doubt qualifies, and given the construction date and location, it is rather easy to guess that the building is not the original one.

In 1736, colonial government officials granted 66 city-tavern licenses. Another 130 were issued the next year. Of all of the taverns, though, none could compare in importance and reputation to the old one at Church and Broad, first established about 1720 by Charles Shepheard. Situated near the very center of town, within easy strolling distance of the always busy commercial wharves, the storied Shepheard's Tavern (later named "Swallow's Tavern," "Mrs. Swallow's Tavern," "Ramadge's Tavern" and the "City Tavern") was far from the average barroom or hostelry. It did not boast the average clientele, either. Consisting of a main structure and a close-knit complex of outbuildings that would become known as "The Corner," Shepheard's Tavern served as the city's social, political and

cultural epicenter and, undeniably, helped sew together the historic fabric of South Carolina.[170]

Its popularity becomes easier to understand given its time period. In the early 1700s, despite Charleston's rapid growth, there were hardly any public buildings and, of those few, none for legislative functions. As far as Charles Shepheard was concerned, that was just fine. After all, his place, for years, had been serving as the hot spot for entertainment, private business negotiations and assorted court proceedings. Even the Commons House of Assembly liked the place—so much so that the government began renting the space there in 1738 for its regular meetings, a practice that gave Shepheard's upstairs long room, which overlooked Church Street, the sobriquet of "the courtroom."[171]

Assuredly, more than dull bureaucratic babblings took place at Shepheard's. For nearly forty years, its long room was the premier venue for just about every significant city concert. Then, on January 24, 1735, when the *South Carolina Gazette* proudly announced an upcoming performance of *The Orphan, or the Unhappy Marriage*, the latest play to come to the colonies, Shepheard's Tavern, indeed, made history. This performance and the ones that followed, most modern historians now agree, constituted "the first clearly documented record of a theatrical season in America."[172]

Another first for Shepheard's occurred not two years later, on October 28, 1736. "A lodge [Solomon's Lodge no.1] of Ancient and Honorable Society of Free and Accepted Masons was held, for the first time, at Mr. Charles Shepheard's, Broad Street." This organization was among the very first Masonic lodges in colonial America. This Masonic connection continued into the following century, when the Mother Council of the Ancient and Accepted Scottish Rite of Free Masons was founded on the same site in May 1801.[173]

As for other areas within Shepheard's and the rest of the Corner, those too should not go without mention. By 1743, the complex was serving as Charleston's unofficial post office, where ship captains could be hired out for private courier service. They would then deliver these papers and parcels to the addresses in their next ports of call, be they foreign or domestic. Two decades later, as talk of revolution heated up, protesters of Britain's Stamp Act gathered at the Corner, as did the Sons of Liberty—no doubt because it was a far more private setting than the quite public tree on Alexander Street.[174]

Despite all the goings-on at the Corner, the tavern was still by far the busiest place, even after the 1754 construction of South Carolina's first

statehouse mere blocks down Broad Street. Shepheard's long room remained the preferred site for feting South Carolina's royal governors. Plenty of fraternal and charitable organizations—the St. Andrew's Society, among them—called the tavern home at one point or another. In December 1773 (then operating as Mrs. Swallow's Tavern), the establishment was witness to the founding of one of colonial America's earliest chambers of commerce. A decade later, on August 29, 1783, an assemblage of forty-three Continental officers met at the City Tavern and formed the South Carolina Society of the Cincinnati, a fraternal organization that still exists today.

The Great Fire of 1796 burned the original building to the ground, a shock that one Charleston author lamented for years, writing that

> *the most memorable building destroyed…was the old City Tavern, which stood at the northeast corner of Church and Broad Streets, noted in our social and political annals, as having given its name to the old Corner Club, where the forefathers of so many of the present generation used to meet of an evening, to smoke their pipes, and talk over the topics of the day.*

Built in the 1920s and currently a bank, this building now dominates the northeast corner of Church and Broad Streets, the former site of Shepheard's Tavern. *Author's photo.*

Although the owners soon reconstructed a similar building, American independence and the turn of the nineteenth century made Charleston a different place. The state capital had moved to Columbia. Charleston's city hall relocated to Broad and Meeting Streets, adjacent to the former statehouse. The taverns at 48 Broad Street, meanwhile, underwent various name and management changes throughout the 1800s, but what was once Charleston's most important sociopolitical corner in the eighteenth century became just another building in the nineteenth. The building's tavern days gone, two local grocers eventually bought the property and, in 1890, incorporated their business as a commercial company "to buy and sell groceries, liquors, wines, cigars, etc." Sadly, the store's renovations left barely a trace as to the address's former history, and by 1928, only a few lines in an otherwise unnoticed article recorded the property's epitaph:

> *The construction of the new building at the corner of Broad and Church Streets, which is to be occupied by the Citizens and Southern Bank, was commenced early in the month and it is expected that it will be ready for occupancy by the middle of January, 1929. This building will occupy the site of the historic old hostelry, Shepheard's Tavern, just torn down, in which Masonry was organized in the United States.*[175]

THE NEW MARKET COURSE AND WASHINGTON RACE COURSE

There is no marker, no green space, indeed nothing to remind anyone of Charleston's former New Market Race Course, which once attracted hundreds of spectators to the northern "neck" area of the city peninsula. There are plenty who would argue that the site has become, more recently, an entirely different kind of raceway, with Interstate 26 and U.S. Highway 17 converging right over the top of the site.

New Market was by no means the city's first horse-racing track. Several others, including the York Course, Charleston's principal track in the 1740s and early '50s, had all enjoyed success under the careful control of the prestigious South Carolina Jockey Club, first organized in the 1730s. The club members, occasionally referring to themselves as "Brethren of the Turf," considered it their personal duty to "show that racing was the prevailing taste of the age" and looked to promulgate their deep-rooted,

ancestral tradition of racing, breeding and training as well as buying and selling Thoroughbreds within the colony. To do that, of course, a better venue was needed, as was a bigger audience.[176]

By 1754, the York Course's adequacy notwithstanding, the club members had come to agree that it was an "inconvenient distance" from Charleston and therefore an obstacle to increased attendance. So, in 1760, a new one, about one mile north of the city, opened as "The New Market Course," (named either for a nearby property or more likely as an homage to the mother country's celebrated London course of the seventeenth century). Whatever the case, it was a major success for the South Carolina Jockey Club and emerged as the colony's premier horseracing locale, hosting the Charles-Towne Races every year until the beginning of the American Revolution.[177]

Free of war by 1783, Charleston was nonetheless battle-scarred, having suffered much from both the British siege and occupation. The 1780 siege maneuvers had mercilessly plowed right through the once pristine track, leaving it roundly unusable for any sort of recreation. It would take another three years to get New Market repaired and suitable for racing again. Down but not out, the Jockey Club regrouped, reorganized and reasserted itself in spectacular style, eventually restoring its annual race week in February 1786. Of that memorable event, Jockey Club member John Beaufain Irving poignantly wrote, "Here may it be remarked, that if ever there was a 'golden age of racing' in South Carolina, or rather, if ever there was a period destined to be the commencement of a new era in the annals of racing in this State, that period is the one to which we are now referring."[178]

Reinvigorated in its postwar revival and certainly not the type of aristocracy to rest on its laurels, by 1790, the South Carolina Jockey Club was looking to offer a "more vigorous impulse…to the sports of the turf." Though the club was not altogether unhappy with New Market's success and popularity, the track was still well outside the city limits and, consequently, considered as disadvantageous by some members. The following year, the club purchased a substantial tract of land from Robert Gibbes's Orange Grove Plantation and set to work laying out its new "Washington Race Course," a one-mile oval within sight of the Ashley River on the upper peninsula's west side. Appropriately, the club named its new course in honor of the nation's first president, whose cousin, Charleston's own Colonel William Washington, just so happened to be a club member and investor in the new venture.[179]

The move, predictably, doomed the New Market course. No longer a viable or even necessary asset to the Jockey Club, it was unceremoniously

Portion of the grandstands at Washington Race Course. *Library of Congress.*

abandoned, broken up and sold off piece by piece, the track site becoming all but invisible within the next quarter century.

On the other hand, Charleston's brand-new Washington Race Course hosted thousands of spectators at its maiden Race Week in February 1792, an event that soon became a much-anticipated annual competition, which more than one attendee lauded as "the finest horse racing in the south." Still others reported on the brilliant pageantry that Race Week created in Charleston, one mentioning, "On the morning of a race our city pours forth the sport loving portion of its inhabitants. As the hour for starting the horses' approaches, so too may be seen an anxious crowd…a galaxy of beauty."[180]

Race Week would, for the most part, survive the next ninety years and become one of South Carolina's most popular nineteenth-century traditions. There were other times, however, when the track was usurped for violent—even macabre—uses. Duelists, for example, sometimes visited

the area, particularly in the first half of the nineteenth-century, utilizing the large open grounds to settle—oftentimes fatally—their *affaires d'honneur*. The Civil War consumed Charleston between 1863 and 1865, putting Race Week on an understandable hiatus. During this period, Confederate officers converted one section of the racecourse into a prison camp for Union soldiers and another into a cemetery for those who died from the squalid conditions there. The track's infield corralled hundreds of men but offered no basic shelter, medical care or suitable food rations. After only a week or two of captivity, scores died, nearly all from either disease or exposure. Slaves living nearby were given the grim task of removing the bodies to a remote pit, dug somewhere near the main grandstand.[181]

The decades that followed the war were ruinous, and the Washington Race Course fared no better. Some might have even argued that it was in one of the worst parts of the city, having been befouled as an enemy prison camp. Mercifully, the Union dead, who had been so heartlessly interred there, were not forgotten. Dozens of Charleston's newly emancipated African American men and women returned to the Washington Race Course at war's end and worked tirelessly for ten days, exhuming and sorting the jumbled mess of bodies, afterward reburying each in a proper grave with an apposite marker. The new cemetery was eventually enclosed within a whitewashed fence, with "Martyrs of the Race Course" on a sign above the entryway. Then, on

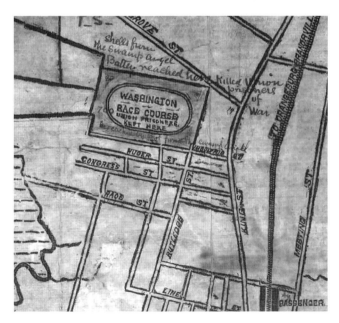

Detail from "Charleston A.D. 1864" map, showing the Washington Race Course as a Union POW camp. *Library of Congress, Geography and Map Division.*

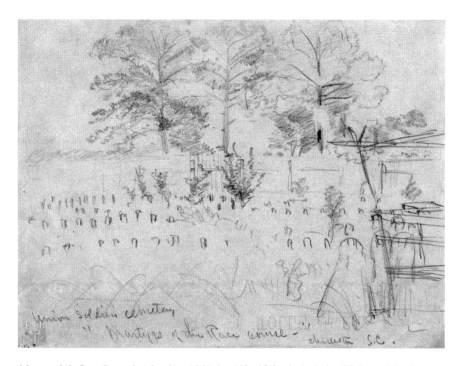

Martyrs of the Race Course sketch, circa 1865, by Alfred Waud, depicting Union soldiers' cemetery at the Washington Race Course. *Library of Congress.*

May 1, 1865, a crowd of thousands, mostly former slaves, led by a throng of "black schoolchildren carrying armloads of roses and singing," unofficially dedicated the cemetery, thus consecrating the site and initiating the nation's first Decoration Day, now observed as Memorial Day. In 1871, the untended graves were removed to a national cemetery in Beaufort, South Carolina.[182]

With the local economy still in tatters well into the 1870s, the whole business of Thoroughbred racing was slowly becoming an "impossible luxury." Although the South Carolina Jockey Club successfully renovated the Washington Race Course in 1877 and, to its credit, was running races again within the year, the enterprise was no longer sustainable by 1882. Two years later, the club closed the racecourse gates forever, all the while watching its membership plummet. Still, the club somehow managed to hold on to its land and even turned a small profit leasing the track's infield for livestock grazing and as the host site for 1901–2's South Carolina Inter-State and West Indian Exposition. Alas, by the end of the century, with only twenty-six members left on the club rolls, its time had run out. A motion was passed to permanently disband in 1899.[183]

Fortunately, unlike New Market, not quite all is lost. Perhaps as a testament to the site's long history and its assorted usages, both good and bad, no big-box store or multilevel parking deck has totally obliterated this fabulous green space. Instead, much of the former Washington Race Course grounds are still somewhat decipherable among the trees, ponds and pathways of Charleston's present-day Hampton Park. Today, Mary Murray Drive follows the same basic path that the horses raced along so many years ago. Although the grandstands, fences and stables are understandably gone (torn down in 1901 to make way for the South Carolina Inter-State and West Indian Exposition), the original front gate piers, four in all, can still be seen—just not in Charleston. Saved from demolition in 1903, the set was presented as a gift to August Belmont Jr., who later installed them at his new Belmont Park in New York. Today, they mark the entrance to gate five and welcome thousands of horseracing enthusiasts to the track's spring and fall meets every year, including the Belmont Stakes, the third leg of Thoroughbred racing's Triple Crown.

7

FROM PLACE TO PLACE

The word *traffic*, as it relates to transportation, appeared in Charleston-area newspapers just over 1,100 times in the 1880s. By 1895, those same papers had broached the subject ten times more often. Clearly, the city was growing, its population, likewise, and the residents were becoming more mobile than ever before. Around the turn of the twentieth century, the South Carolina and Georgia Railroad was running at full capacity. Not long after, automobiles started showing up in the Carolinas, and Charlestonians noticed a buildup of them on their own streets. "It would seem that the horse is about doomed," wrote one journalist in 1908, "the gasoline machines cost only a few hundred dollars more than the horse-drawn apparatus…and can be maintained more cheaply."[184]

Most know—or can easily guess—how the rest of this story goes. Ask any modern-day city planner or councilperson how serious traffic and its control have become to their respective towns, and one is sure to get an involved and detailed earful. Charleston is and was no different. People, it seemed, were everywhere—and needed to get everywhere else. In 1914 alone, Charleston City Council spent over $132,000 on tens of thousands of square yards of sheet asphalt, creosoted wood block, 20,398 yards of concrete and 36,139 feet of granite, all to improve the city walkways and roads. With new tools for new transportation came new roads to carry it all, and a new city began to emerge, one that would, no doubt, have to endure the tribulations of a technologically powered twentieth century.[185]

Some changes were terrifically welcome additions to Charleston's cityscape. Other projects, while likely unavoidable, destroyed, altered or simply paved over much of the Lowcountry's historical milieu.

The "Street Railway"

Decades before Charlestonians had to worry about automobiles racing up and down their neighborhood streets, there was simpler horse-and-carriage traffic that had kept the city mobile. As with other large American cities in the mid-nineteenth century, peninsular Charleston had become severely congested. In 1859, however, several forward-thinking individuals proposed a solution, popularly known as the "Street Railway" system. Through the utilization of horsepower, a network of in-ground rails and a fleet of high-occupancy carriages (or streetcars) would transport passengers throughout the city, both conveniently and cheaply. The idea caught on, and within two years, the investor-led Charleston City Railway Company was hard at work mapping out a grid of track spanning major thoroughfares all over the peninsula. By 1861, it had successfully lobbied the state legislature to pass an ordinance granting it "power and authority…to lay railway tracks through and along city streets within the corporate limits of the city of Charleston, and to use and employ upon such railway tracks sufficient and suitable carriages or cars, to be drawn by horses of animal power, for the transportation of passengers and freight."[186]

Unfortunately, 1861 was not the best year for Charleston or the City Railway Company to undertake any major civic upgrades. After Confederate artillery fired on Fort Sumter that April, the onset of the Civil War occupied practically all the city's manpower and resources for the next four years. Once the war was over, despite Charleston's ruinous condition—both physical and economic—the company, amazingly, reorganized and was quickly back in business. By the summer of 1866, the first lengths of track were in place down Meeting Street near Broad, with cars rolling along them by the end of the year.[187]

The Charleston City Railway system was a major step forward in the urban development of the postbellum South. As successful as it was in its first year, the railway encountered the first bit of trouble a few months into its second. As news about the passage of the Military Reconstruction Act (a measure that ordered the enfranchisement of all male citizens) and other

Printed detail of a Charleston City Railway Company horse-drawn omnibus, circa 1869. *Charleston City Directory, 1869, public domain.*

actions of the federal government became well known, African Americans reacted. On March 27, 1867, dozens of former slaves collectively attempted to board Charleston street cars, acts heretofore prohibited "by rules of the Company." What began as a notable act of civil disobedience swiftly turned sour aboard one car, when its driver "attempted, by direction of the conductor, to throw his car from the track." Obviously, a deliberate derailment such as this might have caused serious injury to all of the passengers, but fortunately, the driver's effort failed. Elsewhere, according to various newspaper reports, "Other cars…were entered in the same way, and the negroes, finding the conductors would not permit them to ride, endeavored to interrupt the travel of the cars by [placing] stones on the track." Luckily, these and other attempts to halt streetcar service or further damage the cars themselves ceased after a few hours, and service returned to normal the following morning.[188]

For the remainder of the nineteenth century, Charleston's street railway traversed the peninsula, mostly without incident. During this time, lines were connected and cars added to connect far-flung urban neighborhoods. Then, in March 1897, the railway underwent perhaps its biggest change, thanks to an important city council ordinance that granted the Charleston City Railway Company "the right and authority…to operate its road by electrical power." Railway drivers eagerly turned in their horses in exchange for efficient and faster power-driven cars.[189]

Operating within an intricate web of electrical lines above and an inescapable footprint of steel tracks below, Charleston's street-railway system, popularly referred to as streetcars or, by the 1900s, "trolleys," was surely

Detail from a "Bird's eye view of the City of Charleston, South Carolina, 1872," showing Charleston's street railway system along King, Calhoun and Meeting Streets. *Library of Congress, Geography and Map Division.*

an integral component of everyday Lowcountry life. Within a few years, downtown trolley service had extended significantly, regularly traveling to suburban neighborhoods, including Summerville and, with the help of a ferry service, Mount Pleasant, Sullivan's Island and Isle of Palms.

For its part, the Charleston trolley system kept up with the growing cosmopolitan city as best it could, but eventually technology intervened. By the mid-1930s, amid the Great Depression, the system was losing money. "Trackless trolleys," known as motor coaches by 1935, were proving to be far more desirable in terms of comfort, speed and, most importantly, cost. "Owners of trolley car lines do not need to be told that they are operating obsolete vehicles," reported the newspaper. "They are taking losses on the services…besides cost, there was overall freedom of movement. The maneuverability of the motor coach is, of course, complete; it is held neither to rails nor to overhead wires. It goes wherever its driver chooses to take it."[190]

By 1938, diesel buses were practically everywhere, and officials began ordering the scrapping of streetcars and their tracks. A few lengths survived, as did some of the cars. Two cars even became a home for one local man, who, upon discovering them abandoned in a storage shed, purchased both and fused them together. Becoming famous as the "trolley car house" on Apollo Road, it lasted until 2005, when the house was dismantled. The cars were allowed to deteriorate in open-air storage. They were finally moved to Charlotte, North Carolina, and preserved.[191]

An electric Charleston trolley passes its soon-to-be replacement, a diesel motor coach, on King Street, circa 1938. *Courtesy of The Charleston Museum, Charleston, South Carolina.*

Today, Charleston's Street Railway system is only visible in old photographs and postcards. The possibility of seeing images like these may not be lost forever, though. In fact, a 2014 "Peninsula Mobility Report," sponsored by the City of Charleston and Historic Charleston Foundation, put forth a rather refreshing set of recommendations to help the city manage its traffic woes. Number one on the list? "Bring back the Trolley system." Recalling specifically Charleston's once popular street railway of the nineteenth and twentieth centuries, the report further mentioned that "a trolley/streetcar system…could provide the basic backbone that is sorely needed, and would also celebrate the historical aspects of the city. With modern technology, expensive substations and overhead catenary wiring [system used to supply electricity to vehicles equipped with a pantograph attachment] would likely not be necessary." With that, there still remains a possibility that Charlestonians may someday see the return of trolleys.[192]

U.S. HIGHWAY 17 AND THE CROSSTOWN

Architect and preservationist Albert Simons knew as early as 1960 that there was trouble ahead. As plans for South Carolina's 221-mile portion of U.S.

Highway 17 took shape across the state's coastal region, he was quick to point out that such development would "intensify the already acute traffic problems arising from the crazy quilt pattern of streets inherited from unguided private enterprise of ante-bellum days."[193]

To be clear, neither the highway nor the peninsular section of it, better known as the Septima P. Clark Parkway or, more commonly, the "Crosstown," is a lost entity. Far from it. In 2007, an average of 54,400 vehicles a day drove over it. That number has unquestionably increased every year since. Opened in 1968, it certainly fulfilled its purpose, connecting the already existing eastern and western parts of the highway that had heretofore simply terminated at the Cooper and Ashley Rivers. Its construction finally freed motorists from having to navigate narrow city streets to travel from bridge to bridge. An aspect of Crosstown history not often discussed, however, is the buildings, nigh whole neighborhoods, that were demolished to accommodate the roadway.[194]

In the 1960s, to their credit, Charleston City Council and the mayor "acknowledged the great displacement that would occur" and that it would most assuredly "change the way of life for many people." However, the Crosstown was a state project, meaning Charleston officials could only do so much in steering its path. As a result, no house or commercial building was entirely safe from the bulldozers, no matter its condition or architectural importance. Near Rutledge Avenue, Sheppard and Coming Streets, for example, despite the "excellent" condition and "high level of owner investment" in many of the properties, full blocks were systematically leveled.[195]

In all, upward of 170 structures were lost to the Crosstown by the late 1960s. Perhaps worse, many affected residents still reflect on how the roadway "bisected historic black mixed income neighborhoods in the city, severing longstanding community connections and creating a highway too dangerous for pedestrians." Another report (this one sponsored by the city itself) put it even more bluntly: "In 1964, U.S. Highway 17 Expressway gorged the historic city of Charleston, scarring our city, dividing neighborhoods, greatly exacerbating drainage problems and creating a visual blight." [196]

The Crosstown was not the only roadway to cause widespread Lowcountry dislocation. Much quieter demolitions were occurring elsewhere, with the advents of Interstate 26 north of town and the expansion of Highway 17 both east of the Cooper and west of the Ashley. For these areas, government officials authorized hundreds of "permits to demolish"—303 over the course of a single year. One reporter described the area as "wracked with

Some Charleston cottages (oftentimes referred to as freedmen's cottages), still survive from the late nineteenth century, but as seen here on Jackson Street, ongoing construction and development since the 1930s has constantly encroached upon these vernacular structures. *Author's photo.*

wreckers," characterizing the projects' breakneck speed as "[l]ike the path of a vicious tornado, a 'destruction line' hops and skips across…areas where the highway construction has been centered.…For numerous reasons, demolition is evident throughout the Port City."[197]

Perhaps the best proof of the human price paid for the sheer volume of destroyed and altered properties lies within the archives of Historic Charleston Foundation. There, over 2,200 photographs taken by the South Carolina Department of Transportation (SCDOT) prior to the actual construction of the Crosstown and stretches of Highway 17, dutifully survey "houses, apartment buildings, freedman's cottages, mobile homes, commercial and industrial buildings, churches, schools, gas stations, restaurants, grocery stores and corner markets, garages, sheds, outhouses, and other outbuildings," practically all of which would soon fall victim to highway development.[198]

Certainly, not all of these structures—outhouses and sheds, for instance—were historically significant. Historical relevance aside, however, it is impossible to overestimate the emotional toll. Clearly visible in many of the photos are the residents themselves, most of whom would soon be forced to relocate. Well over a dozen church congregations had to find or build new sanctuaries. Business owners had to temporarily close up shop— some never reopened.[199]

Prominently featured among the photographed buildings are over one hundred "freedmen's cottages." Mostly built from the late 1870s into the early 1900s, these plain, wooden, single-level, gable-roofed houses are often mistaken (as the name suggests) as dwellings for Charleston's newly emancipated slaves. Contemporary research has proven this notion inaccurate, and many "were built and occupied by people of many ethnicities." Nevertheless, these cottages were arguably Charleston's best examples of vernacular architecture, each exhibiting "local needs, traditions, and construction materials." Of the thousands of these cottages that once peppered Charleston, only a few dozen remain. [200]

THE COOPER RIVER BRIDGE

"I thought I'd miss it," opined one Mount Pleasant resident when reminiscing about the old Cooper River Bridge, "but I don't. It might have been okay to look at, but having to use it all the time was dreadful." Nearly every day

for half a century, locals drove over the narrow two-lane cantilevered bridge, which spanned the waters between Charleston and Mount Pleasant. "Each trip was an adventure," another recalled, "Forty-foot tractor trailers routinely met you in the opposite lane. I am sure the good Lord rode with us each day as we were spared any serious injury during those rides!"[201]

Upon its opening on August 8, 1929, the soon-to-be named John P. Grace Memorial Bridge, an homage to the former Charleston mayor (but better known at the time as the "new bridge" over the "old Coop"), was nothing less than a godsend to area residents. Connecting Mount Pleasant on the east side with Charleston on the west, it measured just under 2.7 miles long, reaching a maximum height of 155 feet. Besides the transportation benefits, its massive steel skeleton provided a commanding backdrop that almost instantly endowed the Lowcountry's once-unobstructed horizon with an undeniably urban character. Yet, impressive as the bridge was upon its completion, times had surely changed by the 1960s.

By then, the Grace's steep grades (over 6 percent in some places) and its narrow, ten-foot-wide lanes were deemed insufficient to handle the nearly twelve-thousand-vehicle-per-day average. Additionally, bigger and much faster cars oftentimes led to some close calls—so much so that, by 1960, the police began offering the services of escort drivers, who, upon request, would gladly "take the wheel for those who feared driving over the bridge."[202]

The first bridge over the Cooper River, shown here as it nears its 1929 completion. *Courtesy of The Charleston Museum, Charleston, South Carolina.*

Some small improvements were made. In 1959, engineers widened a short section to allow for breakdowns, but that step alone proved totally inadequate. Add to that its rather low weight-bearing capacity, and the Grace Bridge just could not keep up with the ever-increasing metropolitan traffic volume. Fortunately, the state launched an ambitious plan to help relieve at least some of the traffic burden, which the Grace had endured for years. In 1966, the Silas N. Pearman Bridge, named for the state highway commissioner, was completed. The newer, wider and certainly less steep span ran adjacent to the Grace on the south side. The Grace was converted to one-way, southbound traffic, while all three lanes of the new Pearman were northbound, except in cases of emergency or unusually heavy traffic, when one lane could be reversed.

By 1979, though, both Cooper River bridges were deemed to be "functionally obsolete." Not two years later, inspectors determined that the older Grace was no longer "structurally able" to handle any vehicle weighing more than fifteen tons, and the state permanently reversed one lane of the newer Pearman for heavy trucks. The bridges somehow held together, despite time and weather working cruelly against them. In 1998, an environmental impact statement produced by the U.S. Department of Transportation and the Federal Highway Administration stated: "While travel demands have been increasing…the operating conditions on the bridges have been deteriorating." They were being generous.[203]

By the mid-1990s, deficiency-test scores for the bridges were at an all-time low—the Grace with a miserable grade of four points out of a possible one hundred. For all their flaws, little could be done to remedy the crisis, and a serious lack of highway-improvement funds gave both structures a lengthy stay of execution. By the late twentieth century, inspectors were spot-checking the Grace and Pearman every six months, paying particularly close attention to the pin-and-hanger joints, which connected the steel framework to the actual roadway. Losing just one, an examiner apprehensively mentioned, "the whole structure would drop into the water."[204]

Acknowledging that "[t]he Cooper River bridges now must be replaced and it is imperative that today's leaders plan effectively," the Berkeley-Charleston-Dorchester Council of Governments decided that the Grace and the Pearman Bridges' time had come. On October 25, 1997, they successfully lobbied the South Carolina State Infrastructure Bank Board and soon secured funding for a bridge, which would eventually get Lowcountry drivers off borrowed time.[205]

One concrete support pier from the 1966 Pearman Bridge was saved as a monument. Painted vibrant colors, it now stands alone near the corner of East Bay and Lee Streets. *Photo by English Purcell.*

Calling for a mammoth suspension design with twin diamond-shaped towers and an eight-lane roadway, construction on Charleston's new bridge, named for state senator Arthur Ravenel Jr., was underway by 2001. Three years later, the first cables were in place. In March 2005, the final road slab was laid, and the new bridge opened to traffic the following July. Today, the Ravenel is third-longest cable-stayed bridge in the Western Hemisphere. But, more significantly, it is by far the most spectacular feature on South Carolina's Highway 17. As hoped for, the Ravenel Bridge does quite well in handling the demands of urban Charleston on both sides of the Cooper River.

As dramatic as the rise of the new bridge was, so too was the gradual destruction of the two old ones. Off and on over the next two years, residents citywide heard—and, at times, felt—unmistakable, albeit intermittent, booms from explosives detonating and disintegrating the old bridges. Watching these quick demolitions became quite a popular form of entertainment for those willing to walk down to the riverfront.

With the new bridge in service and the old pair officially a memory by 2007, Charlestonians for the most part eagerly embraced the eased traffic from the peninsula to Mount Pleasant and back. Of course, not every remnant of the old bridges was completely lost. During its razing, pieces of the Grace Bridge were hot collectibles, showing up in local antique shops and online auction sites. The authenticity of such chunks still remains questionable. Additionally, Charlestonians are nothing if not amenable to holding on to at least some remnants of an old thing or two. In this case, several preservation-minded individuals persuaded city officials to keep a rather large reminder. On East Bay Street today, a casual observer might be surprised to see what initially appears to be an undecorated *torii* gate, reminiscent of the entrance to a Japanese Shinto temple. Closer inspection reveals, however, that it is merely a solitary, concrete support pier. This monolithic artifact is all that physically remains of the once mighty Silas N. Pearman Bridge.[206]

8

THAT WHAT LIES BENEATH

There has always been a notion among the citizenry that, should one dig just about anywhere in town, one would probably recover more than just a few handfuls of dirt. After all, opined one resident, "Tiny buried materials are enough to unlock a whole chapter of Charleston's history."[207]

It should come as no surprise that peninsular Charleston is so archaeologically rich. During the eighteenth century, as the old fortification walls became less and less necessary—and more and more expensive to maintain—many portions, while not destroyed outright, were "simply buried beneath the demolition rubble, with newer city features constructed on top of the foundation." Expansion was no different in the nineteenth century. Cellars, instead of being cleared out, were simply filled in and built upon, permanently encapsulating all that had been once discarded. Houses themselves were "built one on top of another," with "debris left behind…in the ground like layers of an onion."[208]

Today, discoveries are commonplace, whether during massive commercial developments or simple property improvements. In 2003, on George Street, a homeowner digging a post hole unexpectedly unearthed a six-pound cannonball. Given the property's proximity to the 1780 British siege lines, it was likely fired during the artillery attacks that preceded the city's capitulation. Years later, on Huger Street, crews clearing land for an apartment building exposed a soil stratum featuring countless ceramic sherds, which one on-site archaeological professional assessed as significant.

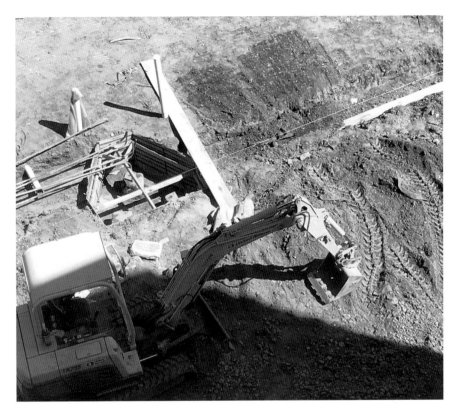

New construction on Huger Street unwittingly revealed a definitive soil feature (seen top center) and dozens of ceramic fragments. Usually, soil-color variations like the one shown here hint of previous human activity from past centuries. *Photo by Sarah Platt.*

If only there had been a little time and money to study these materials and the site itself, before the pile drivers and concrete trucks moved in, who can say what valuable data might have been gleaned.

The recognition of the potential loss of irreplaceable materials is not new. As early as the 1970s, a pair of women first took serious notice of all that was being lost to new construction. Some planned archaeological excavations had been performed in the previous decade, but many other opportunities were lost to Charleston's "extensive urban renewal." Dr. Elaine Herold, a professionally trained archaeologist and wife of The Charleston Museum director, lamented, "[V]aluable resources…are sometimes being destroyed by local and state governments, and private developers….Anything that digs an archaeological site destroys an archaeological site." Working right alongside Herold was Martha Zierden, who would become The

THAT WHAT LIES BENEATH

Charleston Museum's first full-time curator of historical archaeology in 1985. Together with Herold and later on her own, Zierden took advantage of every available opportunity to excavate, map and catalogue sites around town, all the while stressing the importance of her field study, in general, and understudied "investigations into underrepresented people" and "to fill out the details of daily life."[209]

With all that can be found and studied beneath Charleston, it seems quite curious that the city does not yet have any type of archaeology ordinance in place, a means of ensuring that future construction-project sites undergo some minimal surveying, sampling or excavating prior to getting underway. Even though there exist a few vague federal and state laws that "require property owners to consider archaeological resources," these unfortunately apply only to government-initiated projects. No such mandates exist for private developers, and far too often, the outcomes are devastating. In 2015, Charleston's Midtown Project included construction of a hotel, parking garage, office and retail spaces, all within a block of King and Meeting Streets. The consensus among local archaeologists was that "there were remnants of British siege lines in 1780 that could have been [located] on portions of that property." That opportunity was lost.[210]

Assuredly, the enactment of archaeology ordinances is not a novel idea. Other Eastern Seaboard cities, such as Alexandria, Virginia, Albany, New York, and St. Augustine, Florida, have had archaeological mandates on their books for years. St. Augustine's regulations specifically cite what needs to be taken into account: "a direct relationship of archaeology to the economic wellbeing of the city and the present and future needs, public health, safety, morals and general welfare of its citizens and its visitors."[211]

Those in Charleston's preservation realm agree. A few news writers and editors do, too, one even reminding the public: "A draft archaeology ordinance has been in the works for years, but it never has reached the desks of City Council members—partly because it always got pushed to the back burner." Another editorial demanded, "It's time to get something on the books. Preservation should be underground as well as above-ground. And Charleston's laws should make sure that the city's priceless archaeological record isn't lost in the flurry of development." In 2016, the mayor suggested, "Maybe our development process should make developers more aware of what's out there."[212]

Thankfully, there is some good news. Today, several local institutions (The Charleston Museum, Drayton Hall and Historic Charleston Foundation, among them) and even some private residents advocate the importance of

preserving and recording historical data from both above- and belowground sites. At Drayton Hall, for example, ongoing archaeology continually uncovers vital data, which give valuable insight to all facets of life associated with this unique historic site. One recent excavation underneath the existing main house revealed evidence that an earlier plantation structure had once stood in roughly the same place. On the peninsula, the Board of Officers for two of the nation's oldest militia units, the Washington Light Infantry (1807) and Sumter Guards (1819), has twice barred development in Marion Square, a property jointly owned by the organizations. According to its deed, the board, in conjunction with the City of Charleston, manages Marion Square as a public park. In 2013, when the old Charleston County Library, adjacent to the park on King Street, was razed, Washington Light Infantry members, with the permission of nearby property owners, collected and catalogued artifacts from the demolition site and other affected areas. They recorded the location of a partially exposed fifty-thousand-gallon cistern, once part of the 1887 Charleston Central Police Station. Furthermore, in a

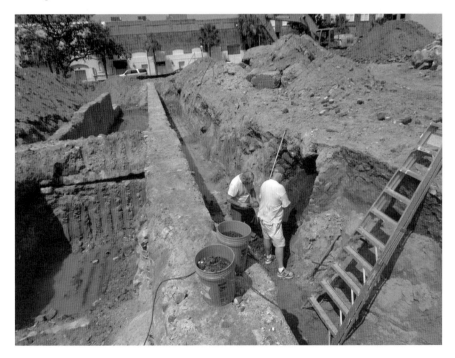

Officers of the Washington Light Infantry examine revealed soil features and fragments after a building demolition adjacent to Marion Square. *Photo by LTC Dale Thieling.*

deep trench, with little more than hand tools, they recovered and catalogued artifacts likely associated with the former Citadel officers' quarters, which once occupied a portion of the demolition site.[213]

"THE ACCIDENTAL PRESERVATIONIST"

The new owner of an elegant—but not ostentatious—single house on Laurens Street was just beginning to realize what was in store for her. Needing to address "some basic maintenance issues," the homeowner decided early on that she needed a better sense of the original builder and owner, merchant Simon Jude Chancognie. He had first come to the city in 1801, representing the French Commissary General Department as a commercial agent, but soon became a successful merchant. Among the finds in her careful research, the homeowner discovered that, although the street-side historic marker listed the home's construction in 1816, documentary evidence pegged the year as 1810.[214]

Forty-eight Laurens Street, one of the first houses acquired by Historic Charleston Foundation for its "Ansonborough Rehabilitation Project," came with restrictive covenants attached, quite common to ensure the preservation of original building fabric. This admitted "accidental preservationist" unwittingly set herself on a course of tireless research and discovery, perhaps unmatched among contemporary private homeowners. In one aspect of her investigations, she had a distinct advantage. The home was remarkably unaltered from its original state. Intricately carved acanthus leaves, gobbed with multiple paint layers, still adorned the second-floor parlor. A lavish King of Prussia stone mantel, to be sure an unusual piece for its time and place, still surrounded a fireplace. Microscopic paint analysis exposed the original color schemes throughout the house. A small fragment of the stair hall wallpaper was also discovered and just happened to match a larger one stored away undisturbed in an archival drawer at The Charleston Museum, salvaged during a 1930s renovation.[215]

Even as Chancognie's former residence continued to reveal much of its aboveground history, the current owner decided the time was ripe to look elsewhere. There had once been a unique structure on the premises, possibly the first of its kind in Charleston. Unlike many Americans in the early nineteenth century, the French had readily accepted bathing as a necessary component of personal hygiene. In keeping with this regimen,

Chancognie had constructed a "bathing-house" somewhere on the grounds. Unfortunately, this "facility" was long gone, and finding it would provide a whole new learning experience. Undeterred as ever and enlisting none other than Martha Zierden of The Charleston Museum, she began to learn archaeological procedures and techniques that could potentially help her find the site of the elusive bathhouse.[216]

Despite the undeniably laudable efforts—and expenses—willingly undertaken by some residents such as the one on Laurens Street, the city remains, as one preservation professional put it: "at a critical point…. We've never had the kind of growth we're having now….We're losing more history every day than we're finding." Archaeological efforts continue citywide, but there is hardly ever time or funding enough to compete with the speed of the city's twenty-first century growth. Thankfully, there are still instances where archaeological examinations and excavations have recovered and conserved some of the city's past.[217]

THE BEEF MARKET

There are bountiful archaeological sites all over Charleston's urban peninsula, where, if thorough examinations had not been conducted, irreplaceable data would have been completely lost. What had once been the city's most vibrant eighteenth-century marketplace was near instantly erased by the Great Fire of 1796. Today, Charleston City Hall, on the corner of Meeting and Broad Streets, and adjacent Washington Square stand upon the same property, which long before becoming the seat of local government, had been an everyday destination for the local citizenry. The place had been mapped out and reserved for what the Grand Council of Carolina designated as "publick [sic] structures." Though it would be a while before any actual buildings would occupy these "common lands," within a few years, the general populace had collectively, albeit informally, purposed the area for a public marketplace, ideal for the buying and selling of assorted foodstuffs. Government officials properly decreed the corner a "market square" in 1692.[218]

While the corner of Meeting and Broad might seem like a strange place for a market today, given the prominence of the surrounding buildings, that was definitely not the case at the turn of the eighteenth century. Conveniently, this site was mere yards from the western entrance of the soon-to-be walled

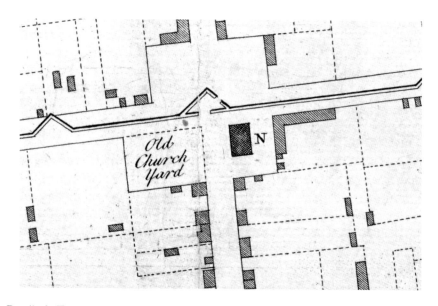

Detail of "The Ichnography of Charles-Towne, at High Water," 1739, showing Charleston's "New Market" (marked "N" and later to be commonly called the "Beef" Market"), on the present-day corner of Broad and Meeting Streets, just inside the city wall. *Map reproduction courtesy of the Norman B. Leventhal Map Center at the Boston Public Library, public domain.*

city, its proximity providing easy access to "wagons manned by farmers and slaves bringing produce from the surrounding country." Livestock owners were especially grateful for this closeness, as they did not have had to drive their herds through town. Perhaps another benefit to this site's perimeter locale was that it kept at least some of the unpleasantness associated with butchering livestock contained. During this period, Charleston was no different from other towns throughout Europe, having its own version of an *Echorcheire*, or delicately translated, "an outdoor slaughterhouse," within its marketplace. Here, in a bloody, smelly and quite public manner, meat workers "cut and chopped and sawed amid discarded body parts and offal." It is likely that, because of this sordid and poorly controlled environment, by the 1730s, the market had had multiple complaints lodged against it, all of which finally gave rise to a general demand for a brick market building (completed in 1739).[219]

With the new building came tighter government oversight and better all-around management. However, though twenty years had hardly passed, the structure was in a state of disrepair, its deplorable appearance only enhanced by the area's disagreeable odors. By 1760, the decrepit brickwork of the

market was rebuilt, earning praise as "a neat building, supported by brick arches, and surmounted by a belfry."[220]

To its credit, this new corner market and its building served the community well. As Charleston's population rapidly grew, so too did its need for separate and more diversified marketplaces. Across from the eastern terminus of Tradd Street, a new "Lower Market" was established, selling cuts of "hog or sheep...lamb, kid or goat." Over on Queen Street, another supplemental one sold fruits, vegetables and fish. Meanwhile, the original Meeting and Broad Street site was recommissioned as the "Beef Market," and although its offerings became more limited, it still flourished as a commercial hub, even becoming a sort of anchor point for other businesses. Local tobacconists Stewart and Barre, for instance, operated a busy shop "opposite the back side of the Beef Market," while silversmith and jeweler James Askew, from his place at "No. 81, the Corner of Beef Market Square, in Broad Street," advertised that "any device that Fancy can suggest" could be readily purchased there.[221]

Furthermore, to hopefully avoid the filthiness of previous markets, a five-member, legislature-appointed board, known as the "Commissioners of the Markets" required each site to "[e]mploy a person to keep each of the markets clean, and they be obliged to sweep the markets twice a day, wash the stalls once every day, and the pavements in and round the markets, three times each week; and to be very attentive that they do their duty and keep the markets as clean and sweet as possible."[222]

Though the popular Beef Market would change addresses for a brief period in 1789, by 1794, it was right back at its original location, catering to the many needs of a hungry public. Business continued there unabated for another two years, until the Great Fire destroyed the Beef Market once and for all. Operations were hastily relocated to the Lower Market opposite Tradd Street on East Bay until 1799, when the city closed it and enlarged the Queen Street location. A year later, once renovations were complete, it became the city's only public marketplace.

Back at Meeting and Broad, city council, after some brief debate, agreed to pass the charred lot to the federal government, "for the purpose of erecting an elegant building thereon for a Banking House." The regal Adamesque structure, completed in 1804, was one of eight branches of the First Bank of the United States, operating regionally as the "Office of Discount and Deposit." When the U.S. Senate failed to recharter the bank in 1811, the trustees liquidated its assets and conveyed the building to the State Bank, which, in turn, sold it to the city in 1818. It was soon

after converted to Charleston City Hall and has served the public in that fashion ever since.[223]

Built on an elaborate raised basement, the natural inclination is for passersby to look up at the impressive structure, which is exactly what most did for 180 years. It was not until 1984 that a few folks decided to look down. With the city's permission, a small Charleston Museum crew with an even smaller budget excavated a single five-by-ten-foot plot just behind the building, "to test…that some evidence for a market could be found." The dig revealed multiple "undisturbed deposits from the entire market period.…The soils were so filled with artifacts and animal remains that the small unit took four people working an entire week to excavate." As a matter of fact, this one exploration was so productive that neither the archaeologists who worked on it nor city officials ever forgot its significance. In 2004, city hall's bicentennial, major renovations were scheduled for the building. But before any of that happened, the project architects made a call to The Charleston Museum. It was time to expand on the work that had begun twenty years earlier.[224]

Happily, if not a bit amazingly, city hall's colossal foundation had corrupted hardly any Beef Market remains, and had, in effect, sealed and protected many of them. In the bottom few inches of several three-foot excavations in the basement, museum crews discovered a portal into Charleston's 1690s open-air marketplace that revealed ten thousand artifacts, such as "bones, teeth and other debris."[225]

After all the artifacts were catalogued and the dig site mapped, the area was backfilled and the renovation/restoration of city hall proceeded. Following completion of the project, an informative exhibit was installed near the basement entrance, highlighting the historic Beef Market and the archaeology that uncovered many of its secrets. This exhibit and the second-floor council chamber are open to the public most weekdays.

At the end of 2017, the U.S. Census Bureau's American Community Survey calculated that the Charleston metro area population was increasing at a rate of three times the national average, with twenty-eight new residents moving in every day. Indeed, it is a popular place. So popular, in fact, that there are those who would argue that Charleston has lost too much of what it once was. While a notion such as this should be regarded with some objectivity, when contemplating the sheer age of the city and then coupling it with modern growth, loss is not only expected but also unavoidable. It is impractical to think that all buildings, regardless of their age or condition, can be saved. Natural disasters—predictable, at

times, but never preventable—are just one category of calamity that will doubtlessly continue to damage or flat-out destroy the city's historic fabric.

Much to their well-deserved credit, Charlestonians unflinchingly continue to "study the values of its past in order better to reconcile them with the necessities of the future." What is more, the city is especially fortunate to have a public that has remained vigilant to a variety of threats, ever conscious of what has gone wrong over the years. Obviously, not all efforts have been successful, but it is tough to imagine there exists any other community that has collectively embraced—and fought for—the preservation of its own history more than Charlestonians have since 1920. Charleston learns from its past. It always has.[226]

NOTES

Chapter 1

1. Albert, "Scratching the Surface."
2. Riley, "Remarks."
3. Ramsay, *History of South-Carolina*, vi, 1.
4. *News and Courier*, January 25, 1885.
5. Munday, "Dixie Furniture."
6. Avakian, "Why Charleston"; Munday, "Charleston Makes List"; McDermott, "Charleston Again."
7. "How Much Is Too Much," *Post and Courier*, June 19, 2017.
8. *News and Courier*, January 26, 1936; Crisp et al., "Compleat Description."
9. Butler, "Unresolved Fury."
10. Butler et al., "*Archaeology at South Adger's Wharf*," 3.
11. Marley, *Wars of the Americas*, 2:349; Butler, "Horn Work."
12. McCord, *Statutes at Large*, 7:65.
13. Butler et al., "*Archaeology at South Adger's Wharf*," 27.
14. Ibid.
15. McCord, *Statutes at Large*, 7:19.
16. Ibid.
17. Butler, "Bee's Ferry"; Smith, "Some Forgotten Towns," 205.
18. McCord, *Statutes at Large*, 7:205; Butler, "Bee's Ferry."
19. Zierden and Anthony, *Willtown*, 24.
20. Ibid., 56.
21. Smith, "New London," 30.

22. Zierden and Anthony, *Willtown*, 1.
23. Behre, "Development Races Ahead."
24. Trinkley, "Reconnaissance of the Brown Cemetery," 3.
25. *News and Courier*, May 26, 1886; *News and Courier*, October 2, 1887; *News and Courier*, June 2, 1887.
26. Ibid.
27. Trinkley, "Reconnaissance of the Brown Cemetery," 4; Manning, *Black Apollo*, 15.
28. Manning, *Black Apollo*, 16.
29. Behre, "Old Neighborhood"; *News and Courier*, June 2, 1936.
30. Norman, "Maryville."

Chapter 2

31. Stoney, *This Is Charleston*, 1–112.
32. Dr. Howard Kurtzman, interview with the author; Fels, "Museum of You."
33. Weyeneth, *Historic Preservation*, 14–16.
34. *News and Courier*, December 14, 1956.
35. *Evening Post*, February 26, 1930; *News and Courier*, March 22, 1930.
36. *Evening Post*, April 10, 1930.
37. Burghardt, "Movement of Architectural Elements," 143.
38. Smith and Smith, *Dwelling Houses of Charleston*, 305.
39. *News and Courier*, September 26, 1950; *News and Courier*, June 8, 1950.
40. *News and Courier*, September 26, 1950; *News and Courier*, April 21, 1952; *Evening Post*, February 5, 1952.
41. Burch, "Building's Fate Uncertain."
42. Mack, *Life of Lafayette*, 33; Uhlendorf, *Siege of Charleston*, 326–29; Behre, "Charleston Officials Authorize Demolition."
43. Lois Lane Properties, "Grand Hotels."
44. Skinner, "Address," 243.
45. *Daily Courier*, March 28, 1838.
46. Ibid.
47. *Southern Patriot*, June 6, 1838.
48. *News and Courier*, January 20, 1883; *Southern Patriot*, June 28, 1838; McInnis, *Politics of Taste*, 103; *News and Courier*, November 14, 1958.
49. Rosenberg, *Jenny Lind in America*, 101.
50. Phelps, *Bombardment of Charleston*, 149; Sanders, "British Royalty."

51. *News and Courier*, June 23, 1958; *News and Courier*, November 13, 1958.
52. *News and Courier*, November 28, 1959.
53. Weyeneth, *Historic Preservation*, 19.
54. Thomas, "Charleston Has New Façade."
55. Burghardt, "Movement of Architectural Elements," 3; *Charleston Evening Post*, March 6, 1952.
56. Wright, *Correspondence of Washington Allston*, 319; Lane, *Architecture of the Old South*, 113.
57. Smith and Smith, *Dwelling Houses of Charleston*, 141–42; Aydin, "Potential of Virtual Heritage Reconstruction," 10.
58. *News and Courier*, September 1, 1885; *News and Courier*, September 20, 1937.
59. Allen, *Bluestocking in Charleston*, 133.
60. Ibid.
61. *News and Courier*, November 21, 1937.
62. Gray, "Restoring the Dock Street Theatre," 43–45.
63. Charleston Museum archives, photo MK 10351, www.charlestonmuseum.org/research/collection/?quicksearch=nathaniel+Heyward+House.
64. Heyward, *Seed from Madagascar*, 24.
65. Edgar, *South Carolina Encyclopedia*, 440; Scarborough, *Masters of the Big House*, 9.
66. Leland "Hidden Room"; Leland, "City's Historic Houses."
67. Preservation Society of Charleston, "1838 (April 27–28) Fire."
68. Burghardt, "Movement of Architectural Elements," 117; Dawson, "Gateways of Old Charleston," 49.
69. *News and Courier*, November 13, 1917; Leland, "City's Historic Houses."

Chapter 3

70. Darlington, "Human Bones Found."
71. Kropf, "Buried Charleston."
72. McCord, *South Carolina Statutes at Large*, 8–9.
73. Journal of the Commons House of Assembly, 14–15.
74. *City Gazette & Daily Advertiser*, August 25, 1794; *City Gazette & Daily Advertiser*, May 15, 1795.
75. Arneman, "Medical History"; Ramsay, *History of South-Carolina*, 281.
76. Pinckney, *Remarks*, 22.
77. Darlington, "Human Bones Found"; Kropf, "Buried Charleston."

78. James Hervey, letter to Andrew Jackson, April 16, 1825, Library of Congress.
79. Meacham, *American Lion*, 12–14; Behre, "History Is a Mystery."
80. *Congressional Record*, 2961.
81. Behre, "History Is a Mystery."
82. Ibid.
83. *News and Courier*, January 18, 1969.
84. *Charleston Courier*, July 10, 1837; *Charleston Mercury*, April 21, 1856; Smith, "Hog Island and Shute's Folly"; Carpiel, *Charleston's Historic Cemeteries*, 10.
85. *News and Courier*, February 1, 1969; Johnson, "Quakers Find Guidance"
86. Brockington & Associates, Papers.
87. Kropf, "Dozens of Graves"; Brockington & Associates, Papers.
88. Brockington & Associates, Papers.
89. Ibid.
90. Ibid.

Chapter 4

91. Williams and Lofton, *Rice to Ruin*, 175
92. Records of Circular Congregational Church; Bryan, *Robert Mills*, 49.
93. Mereness, *Travels*, 398; Freehling, *Prelude to Civil War*, 61.
94. *Charleston Courier*, July 10, 1837.
95. Chiat, *America's Religious Architecture*, 254.
96. Wise, "Earthquake Insurance."
97. Mills, *Statistics of South Carolina*, 446; *Statutes at Large*, November 16, 1700.
98. Slade, "'It's No Way to Live.'"
99. *Evening Post*, July 8, 1940; Sass, "Ten Billion Gallons a Day," 25–30
100. Ibid.; Brown, "Modernizing Rural Life," 68.
101. Edgar, *South Carolina*, 503; Porcher, *History of the Santee Canal*.
102. Shih, *American Water Resources*, 825–26.
103. *Evening Post*, August 29, 1939.
104. Bostick, *Sunken Plantations*; "Waters Rise," *The State*.
105. Edgar, *South Carolina*, 503.
106. "Waters Rise."
107. Stockton, "Old Museum Building."
108. Harvey, *World's Fairs*, 45–46; Hash and Emerson, *Charleston*, 107; Woody and Johnson, *South Carolina Postcards*, 72.
109. Hash and Emerson, *Charleston*, 107.

110. Woody and Johnson, *South Carolina Postcards*, 72; Fantl, "Exposition Architecture," 2–8.

111. *Year Book of 1907*, 39; Rea, "Report of the Director," 3.

112. Ibid.

113. Stockton, "Old Museum Building"; Adams et al., "Blaze Destroys Old Museum."

114. Glass and Gardner, "Demolition Begins."

115. Adams et al., "Blaze Destroys Old Museum."

116. Knich, "'It Was Spectacular.'"

117. *Southern Patriot*, February 16, 1835.

118. Sewell, *"Great Calamity!"*, 92.

119. Knich, "'It Was Spectacular.'"

120. King, "Fire Destroys St. Matthews"; Knich, "'It Was Spectacular'"; Horres, "Tears Flow."

121. King, "Offers of Aid"; Dix, "New Spire Rises."

122. *South Carolina Weekly Gazette*, November, 7, 1783; *City Gazette and Daily Advertiser*, June 11, 1791; *City Gazette and Daily Advertiser*, February 16, 1810; *Southern Patriot*, February 16, 1810; *Southern Patriot*, March 15, 1843; Ramsay, *History of South-Carolina*, 171.

123. Williams and Hoffius, *Upheaval in Charleston*, 18.

124. *News and Courier*, September 3, 1886; *News and Courier*, September 1, 1886; Behre, "First (Scots)."

125. McInnis, *Politics of Taste*, 86; Preservation Society of Charleston, "Armory (1750)."

126. Fraser, "Reminiscences," 101.

127. McInnis, *Politics of Taste*, 86–87.

128. Ibid.; *News and Courier*, October 13, 1886; *News and Courier*, August 31, 1887.

Chapter 5

129. *News and Courier*, January 25, 1885.

130. Journal of the Commons House of Assembly, 479.

131. Denison, *Shot and Shell*, 259.

132. Behre, "In Soil near Charleston's Elizabeth Street."

133. Ibid.

134. Muller, *Treatise*, 232.

135. Behr, "When Upper King Was a Battlefield."

136. *Original Papers Relating to the Siege of Charleston*, 37.
137. Ibid., 40.
138. Ibid.
139. Darlington, "Key Piece of Revolutionary War."; Martha Zierden (Curator of Historical Archaeology, The Charleston Museum), interview with the author, June 21, 2017.
140. Butler, "Brief History of Marion Square, Part 2."
141. Marszalek, *Diary of Miss Emma Holmes*, 374.
142. *New York Times*, July, 22, 1863; Lossing, *Pictorial History of the Civil War*, 202.
143. Bostick, *Charleston Under Siege*, 24
144. Ibid.
145. Wise, *Gate of Hell*, 281.
146. Roman, *Military Operations*, 130.
147. Wise, *Siege Train*, 189
148. Scott et al., OR 35/1, 169; Riply, *Siege Train*, 202.
149. Douglas W. Bostick (Executive Director/CEO, South Carolina Battlefield Preservation Trust) interview with the author, May 15, 2014.
150. Hamer, "Barbeque, Farming and Friendship," 63; Krammer, *Nazi Prisoners of War*, 208.
151. Hamer, "Barbeque, Farming and Friendship"; Berry, "For Some, a Relic Stings."
152. Berry, "For Some, a Relic Stings."
153. Ibid.; Behre, "Last Remnant."
154. Berry, "For Some, a Relic Stings"; West, "German POW Camp."
155. Knich, "Chimney from World War II POW Camp"; Behre, "Last Remnant."

Chapter 6

156. Edgar, *South Carolina*, 174.
157. *News and Courier*, February 18, 1912.
158. Butler, *Votaries of Apollo*, 76; Porter, *History of a Work of Faith*, 179; McGinnis, *Politics of Taste*, 25.
159. *City Gazette*, August, 14, 1792.
160. *Southern Patriot*, July 25, 1833
161. *Southern Indicator*, August 6, 1921.
162. Sonneck, *Early Concert-Life*, 25; Seilhamer, *History of the American Theatre*, 48.

163. Davis, *Religion and the Continental Congress*, 67.

164. Edwards. *Ordinances of the City Council of Charleston*, 15–16.

165. Ogasapian, *Music of the Colonial and Revolutionary Era*, 168.

166. *Charleston Morning Post and Daily Advertiser*, November 11, 1786.

167. *Charleston Morning Post and Daily Advertiser*, November 6, 1786.

168. *Charleston Morning Post and Daily Advertiser*, March 24, 1787.

169. *City Gazette and Daily Advertiser*, August 15, 1788.

170. Edgar, *South Carolina*, 172.

171. Ibid.

172. Butler, *Votaries of Apollo*, 115–16.

173. *South Carolina Gazette*, October, 28, 1736; *News and Courier*, April 11, 1948.

174. Eastman, "Shepheard's Tavern."

175. *Acts of the General Assembly*, 1019; Fraser, *Reminiscences*, 34.

176. Irving, *South Carolina Jockey Club*, 11.

177. South Carolina Jockey Club, *History of the Turf*, 13, 34.

178. Irving, *South Carolina Jockey Club*, 11.

179. South Carolina Jockey Club, *History of the Turf*, 5.

180. Eberle, *History of Charleston's Hampton Park*, 24; Irving, *South Carolina Jockey Club*, 19.

181. Ibid.

182. Blight, "Forgetting Why We Remember."

183. Preservation Society of Charleston, "Washington Race Track"; Blight, "First Decoration Day"; Behre, "Charleston Pillars."

Chapter 7

184. *Evening Post*, September 4, 1908.

185. "Annual Reports," 112–16.

186. Charleston City Railway Company, "By-Laws," 5.

187. Ibid., 111.

188. Hine, "1867 Charleston Streetcar Sit-Ins," 110; *New York Times*, April 2, 1867.

189. *Revised Ordinance*, 319.

190. *News and Courier*, March 19, 1935.

191. Kroph, "Defunct Trolley Cars."

192. Klein, "Charleston Mobility Report."

193. Stoney, Carolina Art Association, *This Is Charleston*, viii; Behre, "Vanishing Landscape."

194. "Executive summary."
195. Roach, "Crosstown," 34, 43–44, 63–64.
196. Felzer, "'Freedman's Cottage' Project"; "Executive summary."
197. *News and Courier*, June 28, 1964.
198. South Carolina Digital Library. "SCDOT Photographs."
199. Ibid.
200. Felzer, "'Freedman's Cottage' Project."
201. Huntington Abbott, interview with the author, October 26, 2017; John Royall, interview with the author, June 14, 2018.
202. *Evening Post*, May 27, 1960.
203. United States Department of Transportation Federal Highway Administration, South Carolina Department of Transportation, *Replacement of the Cooper River Bridges*, 1–10.
204. Ibid.; Berkeley-Charleston-Dorchester Council of Governments, "Revised Application," 2; Vanegeren, "Old Cooper River bridge"; United States Department of Transportation Federal Highway Administration, South Carolina Department of Transportation, *Replacement of the Cooper River Bridges*, 1–10.
205. Berkeley-Charleston-Dorchester Council of Governments, "Revised Application," 2.
206. Hicks, "So How Did You Get that Piece?"

Chapter 8

207. Darlington, "Key Piece."
208. "Old Graveyard," *Post and Courier*, February 7, 2013; Butler et al., *Archaeology at South Adgers Wharf*, 2; Koonse, "Archaeologist Puzzles Over Past."
209. *Evening Post*, January 25, 1977; Zierden and Reitz, *Charleston*, 20; Parker, "Picture of the Past."
210. Parker, "Picture of the Past."
211. City of St. Augustine, "Archaeology Ordinance," Chapter 6, Section 1.
212. "Dig Deeply to Enhance Preservation," *Post and Courier*, June 5, 2016; Behre, "Will Secrets of Charleston's Past"; Behre, "Charleston History Lost"; "Archaeology Law Could Save Buried Treasures," *Post and Courier*, June 5, 2016.
213. Behre, "Marion Square Rises"; LTC Dale Thieling (Executive Officer, Washington Light Infantry) interview with the author, June 17, 2018.

214. Juliana Falk, interview with the author, November 15, 2018.

215. Charleston Museum accession file 1937.5.

216. Falk, interview.

217. Darlington, "Key Piece."

218. Calhoun et al., *Meat in Due Season*, 7; Zierden and Reitz, *Charleston*, 117.

219. Zierden and Reitz, *Archaeology at City Hall*, 12; Kelly, *Great Mortality*, 17.

220. Fraser, *Reminiscences*, 33.

221. *South Carolina Weekly Gazette*, March 8, 1783.

222. *Columbian Herald*, June 1, 1786.

223. Smith and Smith, *Dwelling Houses of Charleston*, 260.

224. Zierden and Reitz, *Archaeology at City Hall* 4; Zierden and Reitz, *Charleston*, 118.

225. Ibid, 121–22.

226. Stoney, *This Is Charleston*, ix.

BIBLIOGRAPHY

Acts and Joint Resolutions of the General Assembly of the State of South Carolina, Passed at the Regular Session of 1890. Columbia, SC: James H. Woodrow, 1891.

Adams, Jerry et al. "Blaze Destroys Old Museum." *News and Courier,* October 19, 1981.

Albert, Gary. "Scratching the Surface: Thomas You, Charleston Silversmith, Engraver, and Patriot." *Journal of Early Southern Decorative Arts* 33 (2012). http://www.mesdajournal.org/2012/scratching-surface-thomas-you-charleston-silversmith-engraver-patriot.

Allen, Louise Anderson. *A Bluestocking in Charleston: The Life and Career of Laura Bragg.* Columbia: University of South Carolina Press, 2001.

Annual Reports, City of Charleston, South Carolina. Charleston, SC: Walker Evans & Cogswell, 1915.

Arneman, Dana P. "The Medical History of Colonial South Carolina." PhD diss., University of South Carolina, 1996.

Avakian, Talia. "Why Charleston Is the Best City for a Vacation in the U.S." *Travel and Leisure,* July 11, 2017. http://www.travelandleisure.com/trip-ideas/charleston-best-us-city-2017.

Aydin, Caglar. "The Potential of Virtual Heritage Reconstruction in Lost Ansonborough." Master's thesis, Clemson University, 2012.

Behre, Robert. "As Development Races Ahead, So Do Efforts to Save African American Settlement Communities." *Post and Courier,* March, 9, 2018.

———. "Charleston Officials Authorize Demolition of One of the City's Most Historic Homes." *Post and Courier,* January 6, 2017.

————. "Charleston Pillars Greet Belmont Fans." *Post and Courier*, June 13, 2005.

————. "Charleston's History Lost Bit by Bit." *Post and Courier*, June 5, 2016.

————. "First (Scots) Celebrates Building's Big Birthday." *Post and Courier*. November 14, 2014.

————. "In Soil near Charleston's Elizabeth Street, a Search for 227-Year-Old Fortifications." *Post and Courier*, June 13, 2017.

————. "Last Remnant of West Ashley German POW Camps Torn Down." *Post and Courier*, November 11, 2018.

————. "Marion Square Rises from Scruffy Past to Be Seen as City's True Center." *Post and Courier*, November 27, 2003.

————. "Old Neighborhood Gets New Attention." *Post and Courier*, November 8, 1999.

————. "This History Is a Mystery." *Post and Courier*, December 18, 2011.

————. "A Vanishing Landscape: Sweetgrass Basket Business Sweet or Sour." *Post and Courier*, June 14, 2016.

————. "When Upper King Was a Battlefield: Only a Fragment Remains of the City's Tabby Fortress." *Post and Courier*, October 21, 2013.

————. "Will the Secrets of Charleston's Past Remain Buried Forever?" *Post and Courier*, June 3, 2016.

Berkeley-Charleston-Dorchester Council of Governments. *Application to the South Carolina State Infrastructure Bank Board for Funding the Replacement of the Cooper River Bridges*. Charleston, SC: October 15, 1997.

Berry, Dan. "For Some, a Relic Stings as a Shrine to Nazism." *New York Times*, April 11, 2014.

Blight, David. "The First Decoration Day." *Newark Star Ledger*, April 27, 2015.

————. "Forgetting Why We Remember." *New York Times*, May 29, 1991.

Bostick, Douglas W. *Charleston Under Siege: The Impregnable City*. Charleston, SC: The History Press, 2010.

————. *Sunken Plantations: The Santee Cooper Project*. Charleston, SC: The History Press, 2008.

Brockington & Associates/Brockington Cultural Resources Consulting. Papers containing documentation concerning archaeological excavation of graves at the Gaillard Performance Hall construction, 2013. Brockington & Associates Charleston office, 498 Wando Park Boulevard, Mount Pleasant, South Carolina, 29464.

Brown, D. Clayton. "Modernizing Rural Life: South Carolina's Push for Public Rural Electrification." *South Carolina Historical Magazine* 99, no. 1 (1998): 66–85.

Bryan, John. *Robert Mills: America's First Architect*. New York: Princeton Architectural Press, 2001.

Bulletin of the Charleston Museum 3, no. 1 (January 1907).

Burch, Sandra. "Building's Fate Uncertain." *Charleston Evening Post*, June 16, 1977.

Burghardt, Laura. "The Movement of Architectural Elements within Charleston, South Carolina." Master's thesis, Clemson University, 2009.

Butler, Nicholas M. "A Brief History of Marion Square, Part 2" *Charleston Time Machine*. June 2, 2017. www.ccpl.org/news/brief-history-marion-square-part-2.

———. "The Horn Work Charleston's Tabby Wall" (lecture). Charleston County Public Library. October 23, 2013.

———. "Unresolved Fury: The 1686 Spanish Raid on Edisto Island." Walled City Task Force. November 5, 2015. https://walledcitytaskforce.org/2015/11/05/unresolved-fury-the-1686-spanish-raid-on-edisto-island.

———. *Votaries of Apollo: The St. Cecilia Society and the Patronage of Concert Music in Charleston, South Carolina, 1766–1820*. Columbia: University of South Carolina Press, 2007.

———. "What (and Where Is Bee's Ferry?" *Charleston Time Machine* (blog). August 18, 2017. www.ccpl.org/news/what-and-where-bees-ferry.

Butler, Nicholas M. et al. *Archaeology at South Adger's Wharf: A Study of the Redan at Tradd Street*. Charleston, SC: Charleston Museum, 2012.

By-laws of the Charleston City Railway Company Incorporated, Jan. 28, 1861. Charleston, SC: Courier Job Press, 1866.

Calhoun, Jeanne A. et al. *Meat in Due Season: Preliminary Investigations of Marketing Practices in Colonial Charleston*. Charleston, SC: The Charleston Museum, 1984.

Carpiel, Frank. *Charleston's Historic Cemeteries*. Charleston, SC: Arcadia Publishing, 2013.

Charron, Katherine Mellen. "Remembering Individuals, Remembering Communities: Septima P. Clark and Public History in Charleston." Lowcountry Digital History Initiative. February 2017. http://ldhi.library.cofc.edu/exhibits/show/septima_clark.

Chiat, Marilyn J. *America's Religious Architecture: Sacred Places for Every Community*. New York: John Wiley & Sons Inc., 1997.

City of Charleston. *US Highway 17 Transportation Infrastructure Reinvestment Project*. Charleston, SC: Evening Post Publishing Company, 2008. www.charleston-sc.gov/DocumentCenter/View/2413.

City of St. Augustine. "Archaeology Ordinance." http://www.citystaug. com/document_center/Archaeology/ArchaeologyOrdinance.pdf.

Congressional Record: Proceedings and Debates of the Second Session of the Sixty-Seventh Congress. Vol. LXII, Part 3. Washington D.C.: Government Printing Office, 1922.

Cooper, Thomas, and David J. McCord, eds. *Statutes at Large Containing the Acts Relating to Charleston, Courts, Slaves, and Rivers.* 22 vols. Columbia, SC: A.S. Johnson, 1841.

Crisp, Edward et al. "A Compleat Description of the Province of Carolina in Three Parts." London: Edward Crisp, 1711.

Darlington, Abigail. "Human Bones Found during City's Drainage Work in Downtown Charleston." *Post and Courier,* March 13, 2017.

———. "Key Piece of Revolutionary War History Possibly Discovered behind Charleston's Aiken Rhett House." *Post and Courier,* June 28, 2017.

Davis, Derek H. *Religion and the Continental Congress: 1774–1789.* New York: Oxford University Press, 2000.

Dawson, C. Stuart. "Gateways of Old Charleston." *Country Life* 39 (1920 –21): 48–49.

Denison, Frederic. *Shot and Shell: The Third Rhode Island Heavy Artillery Regiment in the Rebellion, 1861–1865: Camps, Forts, Batteries, Garrisons, Marches, Skirmishes, Sieges, Battles, and Victories.* Providence, RI: J.A. & R.A. Reid, 1979.

Dix, Kathy. "New Spire Rises on Ruins of Old." *News and Courier,* March 30, 1966.

Eastman, Margaret. "Historic Shepheard's Tavern a Key Broad Street Site." *Charleston Mercury,* December 2014.

Eberle, Kevin. *A History of Charleston's Hampton Park.* Charleston, SC: Arcadia Publishing, 2012.

Edgar, Walter B. *History of Santee Cooper, 1934–1984.* Columbia, SC: R.L. Bryan Company, 1984.

———. *South Carolina: A History.* Columbia: University of South Carolina Press, 1999.

———. *The South Carolina Encyclopedia.* Columbia: University of South Carolina Press, 2006.

Edwards, Alexander, ed. *Ordinances of the City Council of Charleston.* Charleston, SC: W.P. Young, 1802.

Fantl, Ernestine M. "Exposition Architecture." *Bulletin of the Museum of Modern Art* 4, no. 3 (January 1936): 2–8.

Fels, Anna. "The Museum of You Does Not Have a Gift Shop." *New York Times,* October 15, 2017.

Felzer, Lissa D'Aquisto. *The Charleston "Freedman's Cottage": An Architectural Tradition.* Charleston, SC: History Press, 2008.

———. "Collection of the Charleston 'Freedman's Cottage' Project." Avery Research Center, College of Charleston, Charleston, SC, 2006.

Fraser, Charles. *Reminiscences of Charleston: Lately Published in the Charleston Courier.* Charleston, SC: J. Russell, 1854.

Freehling, William H. *Prelude to Civil War: The Nullification Controversy in South Carolina 1816–1836.* New York: Oxford University Press, 1965.

Glass, Mary, and Kurt Gardner. "Demolition Begins on Old Museum." *News and Courier*, October 20, 1981.

Gray, Stephanie E. "Restoring the Dock Street Theatre: Cultural Production in the New Deal Era Charleston, South Carolina." Master's thesis, University of South Carolina, 2016.

Hamer, Fritz. "Barbeque, Farming and Friendship: German Prisoners of War and South Carolinians, 1943–1946." *Proceedings of the South Carolina Historical Association* (1994): 61–94. https://dc.statelibrary.sc.gov/handle/10827/23844.

Harvey, Bruce G. *World's Fairs in a Southern Accent: Atlanta, Nashville, and Charleston, 1895–1902.* Knoxville: University of Tennessee Press, 2014.

Hash, Patton C., and Eric Emerson, ed. *Charleston: Alone Among the Cities.* Charleston, SC: Arcadia Publishing, 2000.

Heyward, Duncan Clinch. *Seed from Madagascar.* Columbia: University of South Carolina Press, 1993.

Hicks, Brian. "So How Did You Get that Piece of the Grace Memorial Bridge? State Offers Very Few Chunks of Old Spans." *Post and Courier*, April 19, 2006.

Hine, William C. "The 1867 Charleston Streetcar Sit-Ins: A Case of Successful Black Protest." *South Carolina Historical Magazine* 77, no. 2 (1976): 110–14.

Horres, Belvin. "Tears Flow as Thousands Watch Blaze." *News and Courier*, January 14, 1965.

Irving, John Beaufain. *The South Carolina Jockey Club.* Charleston, SC: Russell & Jones, 1857.

Jackson, Andrew, and James Hurvey Witherspoon. *James Hervey Witherspoon to Andrew Jackson, April 16, 1825.* 1825. Manuscript/Mixed Material: Library of Congress, https://www.loc.gov/item/maj010703/.

Jacobs, Jane. *The Death and Life of Great American Cities.* New York: Modern Library, 2011.

Johnson, Skip. "Quakers Find Guidance through 'Inward Light.'" *News and Courier*, December 14, 1986.

Journal of the Commons House of Assembly of South Carolina, Nov. 20, 1755–July 6, 1757. Columbia, SC: State Company, 1944.

Journal of the Commons House of Assembly of South Carolina, June 2, 1724–June 16, 1724. Columbia, SC: State Company, 1944.

Kelly, John. *The Great Mortality*. New York: HarperCollins, 2005.

King, Stewart R. "Fire Destroys St. Matthews." *News and Courier*, January 14, 1965.

———. "Offers of Aid Pour in for St. Matthew's." *News and Courier*, January 15, 1965.

Klein, Gabe. *Charleston, South Carolina Peninsula Mobility Report*. Charleston, SC: City of Charleston/Historic Charleston Foundation, 2014.

Knich, Diane. "Chimney from World War II POW Camp to Be Removed." *Post and Courier*, July 15, 2014.

———. "'It Was Spectacular. And It Was Horrible'." *Post and Courier*, January 11, 2015.

Koonse, Christine. "Archaeological Puzzles Over Past." *Evening Post*, September 9, 1979.

Krammer. Arnold. *Nazi Prisoners of War in America*. Lantham, MD: Scarborough House, 1996.

Kropf, Schuyler. "Buried Charleston: Mysteries beneath Your Feet." *Post and Courier*, March 9, 2013.

———. "Defunct Trolley Cars Going to Charlotte." *Post and Courier*, March 17, 2013.

———. "Dozens of Graves Found at Gaillard." *Post and Courier*, February, 1, 2013.

Lane, Mills. *Architecture of the Old South Carolina*. New York: Beehive Press, 1984.

Leland, Isabella. "City's Historic Houses Offer Unique Asset." *News and Courier*, December 14, 1956.

Leland, Jack. "Hidden Room Is Located on 2nd Floor at 18 Meeting." *Charleston Evening Post*, January 28, 1969.

Lois Lane Properties. "The Grand Hotels of Meeting Street: Gone but Not Forgotten." November 21, 2017. www.loislaneproperties.com/resources/the-grand-hotels-of-meeting-street-gone-but-not-forgotten.

Lossing, Benson J. *Pictorial History of the Civil War in the United States*. Vol. 3. Hartford, CT: T. Belknap, 1868.

Mack, Ebenezer. *The Life of Gilbert Motier De Lafayette*. Ithaca, NY: Mack, Andrus & Woodruff, 1841.

Manning, Kenneth R. *Black Apollo of Science: The Life of Ernest Everett Just*. New York: Oxford University Press, 1984.

Marley, David F. *Wars of the Americas: A Chronology of Armed Conflict in the Western Hemisphere, 1492 to the Present*. Vol. 2. Santa Barbara, CA: ABC-Clio, 2008.

Marszalek, John F., ed. *Diary of Miss Emma Holmes, 1861–1866*. Baton Rouge: LSU Press, 1994.

McCord, David J., ed. *Statutes at Large Containing the Acts Relating to Roads, Bridges and Ferries, with an Appendix, Containing the Militia Act prior to 1794*. Vol. 9. Columbia, SC: A.S. Johnson, 1841.

McDermott, John. "Charleston Again Is the Top Small U.S. City for Travelers, Conde Nast Poll Says." *Post and Courier*, October 17, 2017.

McInnis, Maurie Dee. *The Politics of Taste in Antebellum Charleston*. Chapel Hill: University of North Carolina Press, 2005.

Meacham, Jon. *American Lion: Andrew Jackson in the White House*. New York: Random House, 2008.

Mereness, Newton D., ed. *Travels in the American Colonies, 1690–1783*. New York: Macmillan, 1916.

Mills, Robert. *Statistics of South Carolina, Including a View of Its Natural, Civil, and Military History, General and Particular*. Charleston, SC: Hulbert and Lloyd, 1826.

Muller, John. *A Treatise Containing the Elementary Part of Fortification, Regular and Irregular*. London: J. Nourse, 1774.

Munday, Dave. "Charleston Makes List of Most Livable Cities." *Post and Courier*, October 26, 2016.

———. "Dixie Furniture Building in Downtown to Be Torn Down." *Post and Courier*, October 12, 2017.

Norman, Jill. "Maryville Flirts with Oblivion as Time Marches On." *Evening Post*, November 30, 1989.

Ogasapian, John. *Music of the Colonial and Revolutionary Era*. Westport, CT: Greenwood Press, 2004.

Original Papers Relating to the Siege of Charleston, 1780. Charleston, SC: Walker, Evans & Cogswell Co., 1898.

Parker, Adam. "A Picture of the Past." *Post and Courier*, March 18, 2018.

Phelps, W. Chis. *The Bombardment of Charleston, 1863–1865*. Gretna, LA: Pelican Publishing Company, 1999.

Pinckney, Henry L. *Remarks Addressed to the Citizens of Charleston, on the Subject of Interments*. Charleston, SC. W. Riley, 1839.

Porcher, Frederick A. *The History of the Santee Canal*. Moncks Corner: South Carolina Public Service Authority, 1950.

Porter, Anthony Toomer. *The History of a Work of Faith and Love in Charleston, South Carolina: Which Grew Out of the Calamities of the Late Civil War, and Is a Record of God's Wonderful Providence.* Columbia, SC: D. Appleton, 1882.

Post and Courier. "Archaeology Law Could Save Buried Treasures." June 5, 2016.

———. "Dig Deeply to Enhance Preservation." June 5, 2016.

———. "How Much Is Too Much Tourism?" June 19, 2017.

———. "Old Graveyard at the Gaillard?" February 7, 2013.

The Preservation Society of Charleston. "Armory (1750), Watch House (1767), Guard House (1838–1886)." http://halseymap.com/flash/window.asp?HMID=25.

———. "1838 (April 27-28) Fire." http://halseymap.com/flash/window.asp?HMID=48.

———. "Washington Race Track 1792-1900." http://halseymap.com/flash/window.asp?HMID=29.

Ramsay, David. *History of South-Carolina, from Its First Settlement in 1670 to the Year 1808.* 2 vols. Charleston: David Longworth, 1809.

Rea, Paul M. "Report of the Director of the Museum for the Year 1907." *Bulletin of The Charleston Museum* 4, no. 1 (1908): 1–16.

Revised Ordinance of the City of Charleston, South Carolina. Charleston, SC: Walker Evans Cogswell, 1903.

Riley, Joseph P. "Remarks" (lecture). Historic Charleston Foundation, Charleston Gaillard Center, November 11, 2017.

Ripley, Warren, ed. *Siege Train: The Journal of a Confederate Artilleryman in the Defense of Charleston.* Columbia: University of South Carolina Press, 1996.

Roach, Melissa Mann. "The Crosstown: Physical Effects of the Expansion of Highway 17 across the Charleston Peninsula." Master's thesis, Clemson University, 2014.

Roman, Alfred. *The Military Operations of General Beauregard in the War Between the Sates 1961–1865.* Vol. 2. New York: Harper & Brothers, 1884.

Rosenberg, Charles G. *Jenny Lind in America.* New York: Stringer & Townsend, 1851.

Sanders, Jerry R. "British Royalty Has Visited City Before." *News and Courier,* October 23, 1977.

Sass, Herbert Ravenel. "Ten Billion Gallons a Day." *Saturday Evening Post* 223, no. 28 (1951): 24–54.

Scarborough, William Kauffman. *Masters of the Big House: Elite Slaveholders of the Mid-Nineteenth Century South.* Baton Rouge: Louisiana State University Press, 2003.

Scott, Robert N. et al., eds. *The War of the Rebellion: A Compilation of the Official Records of the Union and Confederate Armies.* Washington, D.C.: Government Printing Office, 1880.

Seilhamer, George Oberkirsh. *History of the American Theatre during the Revolution and After.* New York: Haskell House, 1969.

Sewell, Alfred L. *"The Great Calamity!" Scenes, Incidents and Lessons of the Great Chicago Fire.* Chicago: Alfred L. Sewell, 1871.

Shih, Yank-Ch'Eng. *American Water Resources Administration.* Vol. 1. New York: Bookman Associates Inc., 1956.

Skinner, John, ed. "An Address." *American Farmer* 10, no. 31 (1828): 242–44.

Slade, David. "'It's No Way to Live': West Ashley Residents Give U.S. Rep. Mark Sanford, Charleston Mayor an Earful." *Post and Courier*, September 16, 2017.

Smith, Alice R., and Daniel Elliott Huger Smith. *The Dwelling Houses of Charleston, South Carolina.* Philadelphia: J.B. Lippincott Company, 1917.

Smith, Henry A.M. "Hog Island and Shute's Folly." *South Carolina Historical and Genealogical Magazine* 19, no. 2 (1918): 97–94.

———. "Some Forgotten Towns in Lower South Carolina." *The South Carolina Historical and Genealogical Magazine* 14, no. 1 (1913): 198–208.

Sonneck, Oscar G.T. *Early Concert-Life in America (1731–1800).* Leipzig: Breitkopf & Hartel, 1907.

South Carolina Digital Library. "SCDOT Photographs—Properties in the Right-of-Way." scmemory.org/collection/scdot-photographs-properties-in-the-right-of-way.

South Carolina General Assembly. *Journal of the House of Representatives, 113th Session, 1999–2000.* www.scstatehouse.gov/sess113_1999-2000/hj99/19990603.htm.

South Carolina Jockey Club. *History of the Turf in South Carolina.* Charleston, SC: Russell & Jones, 1857.

South Carolina Radio Network. "Details Shared about 37 Historic Graves at Charleston Construction Site." January 2, 2014. https://www.southcarolinaradionetwork.com/2014/01/02.

The State. "The Waters Rise." May 18, 2007. www.thestate.com/latest-news/article14327891.html.

Stockton, Robert. "Old Museum Building Is Architectural Miracle." *News and Courier*, July 1, 1974.

Stoney, Samuel Gaillard. *This Is Charleston: A Survey of the Architectural Heritage of a Unique American City.* Charleston, SC: Carolina Art Association, 1944.

Thomas, W.H.J. "Charleston Has New Façade." *News and Courier*, December 11, 1967.

Trinkley, Michael. "Reconnaissance of the Brown Cemetery." 38CH1619, Maryville Area, City of Charleston. Columbia, SC: Chicora Foundation, February 22, 1996.

Uhlendorf, Bernhard A. *The Siege of Charleston (Diary of Captain Hinrichs)*. Ann Arbor: University of Michigan Press, 1938.

United States Department of Transportation Federal Highway Administration, South Carolina Department of Transportation. *Replacement of the Cooper River Bridges US 17, Over Cooper River and Town Creek Charleston, South Carolina*. Columbia, 1998.

Vanegeren, Jessica. "Old Cooper River Bridge Gets Check Up." *Post and Courier*, January 7, 2004.

West, Katie. "German POW Camp Chimney Denied Protected Status." *Post and Courier*, June 17, 2014.

Weyeneth, Robert R. *Historic Preservation for a Living City*. Columbia: University of South Carolina Press, 2000.

Williams, Roy, and Alexander Lucas Lofton. *Rice to Ruin: The Jonathan Lucas Family in South Carolina 1783–1929*. Columbia: University of South Carolina Press, 2018.

Williams, Susan Millar, and Stephen G. Hoffius. *Upheaval in Charleston: Earthquake and Murder on the Eve of Jim Crow*. Athens: University of Georgia Press, 2011.

Wise, Stephen R. *Gate of Hell: Campaign for Charleston Harbor, 1863*. Columbia: University of South Carolina Press, 1994.

Wise, Warren L. "Earthquake Insurance Rates Edge Up with South Carolina's Heightened Risk." *Post and Courier*, March 18, 2018.

Woody, Howard, and Thomas L. Johnson. *South Carolina Postcards*. Vol. 1. *Charleston, Berkeley, and Dorchester Counties*. Charleston, SC: Arcadia Publishing, 1997.

Wright, Nathalia, ed. *The Correspondence of Washington Allston*. Lexington: University Press of Kentucky, 1993.

Year Book of 1907. Charleston, SC: Walker Evans & Cogswell, 1908.

Zierden, Martha A., and Elizabeth Jean Reitz. *Archaeology at City Hall: Charleston's Colonial Beef Market*. Charleston, SC: The Charleston Museum, 2005.

———. *Charleston: An Archaeology of Life in a Coastal Community*. Gainesville: University Press of Florida, 2016.

Zierden, Martha A., and Ronald W. Anthony. *Willtown: An Archaeological and Historical Perspective*. Charleston: South Carolina Department of Archives and History, 1999.

INDEX

ABOUT THE AUTHOR

J. Grahame Long is the chief curator of the Charleston Museum, America's first museum, founded 1773. He has published numerous articles in local and national periodicals and authored two additional books: *Stolen Charleston: The Spoils of War* (The History Press, 2014) and *Dueling in Charleston: Violence Refined in the Holy City* (The History Press, 2012).

Grahame is a member of the German Friendly Society, an honorary member of the Washington Light Infantry and a former member of the Presbyterian College Alumni Board of Directors. He is married to the Reverend Lissa Long of Westminster Presbyterian Church and has two daughters.